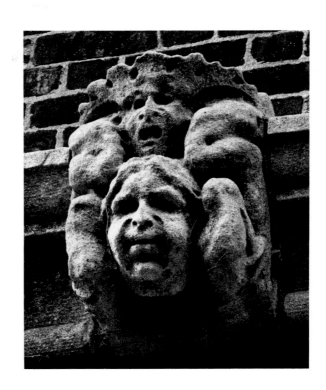

NIGHTMARES
IN THE SKY

GARGOYLES AND GROTESQUES

Text
Stephen King

Photographs
f-stop Fitzgerald

VIKING
STUDIO
BOOKS

VIKING STUDIO BOOKS

Published by the Penguin Group
Viking Penguin Inc., 40 West 23rd Street,
New York, New York 10010, U.S.A.
Penguin Books Ltd, 27 Wrights Lane,
London W8 5TZ, England
Penguin Books Australia Ltd, Ringwood,
Victoria, Australia
Penguin Books Canada Ltd, 2801 John Street,
Markham, Ontario, Canada L3R 1B4
Penguin Books (N.Z.) Ltd. 182-190 Wairau Road,
Aukland 10, New Zealand

Penguin Books Ltd. Registered Offices:
Harmondsworth, Middlesex, England

First published in 1988 by Viking Penguin Inc.
Published simultaneously in Canada

Designed and compiled by Mark Pollard

LIBRARY OF CONGRESS CATALOGING IN PUBLICATION DATA
King, Stephen, 1947–
 Nightmares in the sky.
 1. Gargoyles — Pictorial works. 2. Photography, Architectural.
I. Fitzgerald, f-stop. II. Title. TR659.K56 1988 729'.5
88-20449
ISBN 0-670-82307-4

Printed in Japan

NIGHTMARES
IN
THE SKY

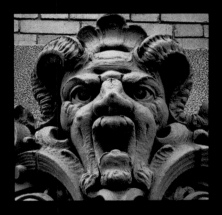

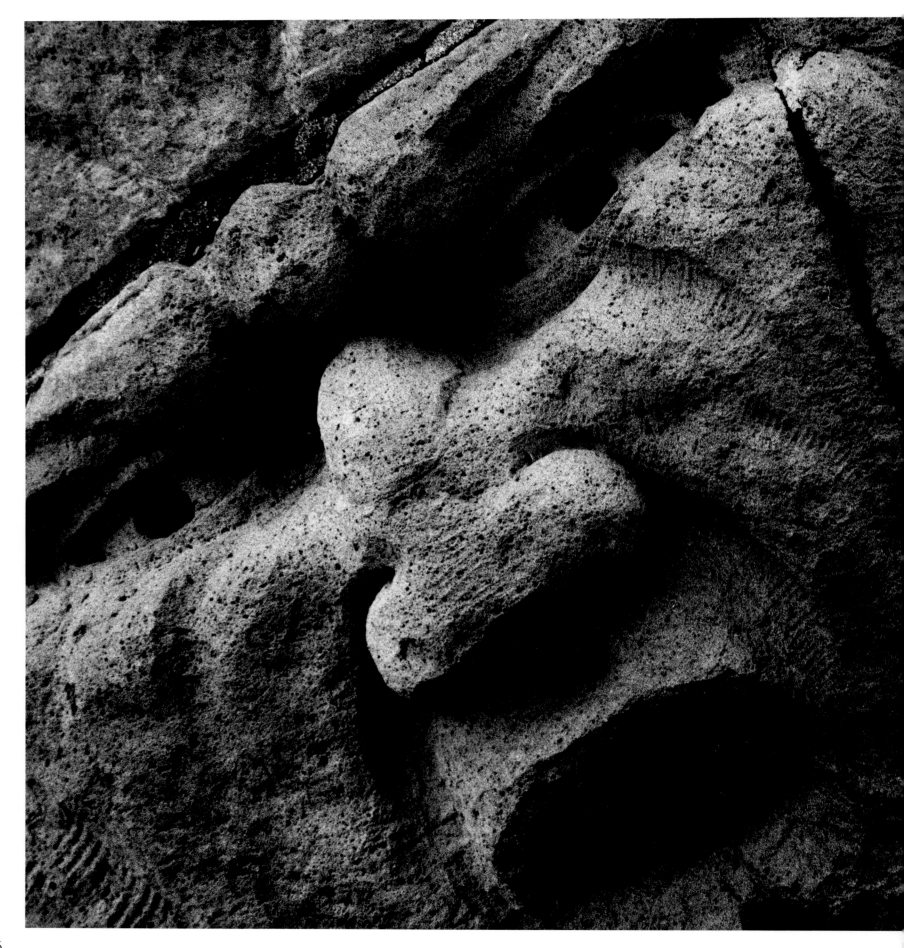

Although Marc Glimcher, who originally asked me if I would write an essay on gargoyles as a kind of preface to the book of extraordinary photographs which follows, thought I would be the "ideal person" for such a piece, I had deep doubts. I have no formal training in the two combined arts—photography and sculpture—which make up the book. In fact, the only artistic endeavor in which I *have* had formal training is the one I practice, writing…and some might claim I've got a hell of a nerve even suggesting that what I do bears any resemblance to art (I can't help remembering Truman Capote's famous remark concerning Jack Kerouac: "That's not writing, that's typing").

Questions of my own artistic ability or lack of it aside, it's an inarguable fact that I *did* receive formal training in the art of writing…and while I was receiving this training at college, I went through the only real dry spell as a fiction-writer in twenty years.

I'm trying to make a point here, and I suppose it's this: although every person who makes and sells works of art rolls his or her eyes at people who say, "I don't know much about art…but I know what I like," there *can* be a deep truth in the statement as well as the *hubris* of the culturally ignorant which most artists sense in the statement (and, unfortunately, their sense is more often correct than not).

I think I went through that dry spell because I was trying not only to know about my art…but to understand what I liked and why I liked it.

This was not good for me.

I am a writer who exists more on nerve-endings than the process of intellectual thought and logic. When someone asked Maxwell Perkins if Thomas Wolfe, whose books Perkins edited, had been a great writer, Perkins snorted, "Hell no! Tom was a divine wind-chime. No more than that."

He didn't add *And no less,* probably believing that it went without saying. Would that it did.

I'm claiming to be the Thomas Wolfe of my generation no more than I am claiming any artistic merit for my work (not that the maker of books, paintings, photographs, *et al.,* has any business claiming *anything* for his work; that is for others to do); I'm only saying that what I write comes from my gut instead of my head, from intuition rather than intellect. In that sense, I am also more wind-chime than writer. We'll leave questions of divinity for the critics, those Jesuits of the artistic sphere, shall we?

This is a rather shy way of telling you why I decided to write about a subject of

which I have no knowledge…and why I acquired none even after I had agreed to write an essay on it. It wasn't laziness; it was a clear, undeniable knowledge that the more empiric knowledge I gleaned on the subject of gargoyles, the worse I would write about them. You see, my *intellect* (what little I have) told me that writing something like this would be like swimming close to a beach that has been posted because of shark sightings.

It wasn't even my gut that told me to go ahead.

It was my nerve-endings.

As I leafed through a selection of the photos which make up this book, staring into stone faces that alternately grinned and leered, sobbed and smirked, snarled and cringed, I felt a sense of horror that was not precisely physical nor precisely mental. It seemed to hold itself balanced on the tips of those nerve-endings to which I have already alluded, refusing to become either revulsion or terror. In short, those photographs refused to become things which, by my ability to define them, would become *my* things. I held them, I would remember them, but they would never be mine.

Looking at those pictures was like having a nightmare awake.
I think I had decided to try my hand at this little essay then, but Marc Glimcher clinched it. "These things are all over the city, you know" he said quietly.

I looked at him, startled. When I thought of gargoyles, I thought of German castles and French cathedrals, of the Hunchback of Notre Dame with his hands plastered over his ears, screaming: "The bells! *The bells!*"

But we weren't in Europe; we were in New York City. I don't live in New York, but I have travelled there every two months or so for the last fifteen years, and am at least familiar with it, and the closest things to gargoyles I could think of, offhand, were the stone lions in front of the New York Public Library. Not very gargoyle-ish, those.

Odd buildings, yes. Lovely buildings, yes. And some, the Chrysler Building for one, the Brill for another, and the Flatiron Building (my favorite New York City edifice and, I think, my favorite in the whole world—take *that*, Taj Mahal), which are each odd *and* lovely…but gargoyles?

Glimcher was smiling a little. "Oh, yes," he said. "But you don't need to feel silly for not noticing them. There are people who live their whole lives here and never see them…or if they *do* see them, they don't *see* them. Do you understand?"

I told him I did, a little, but probably wouldn't have a clear idea of what he was talking about until I actually *saw* some.

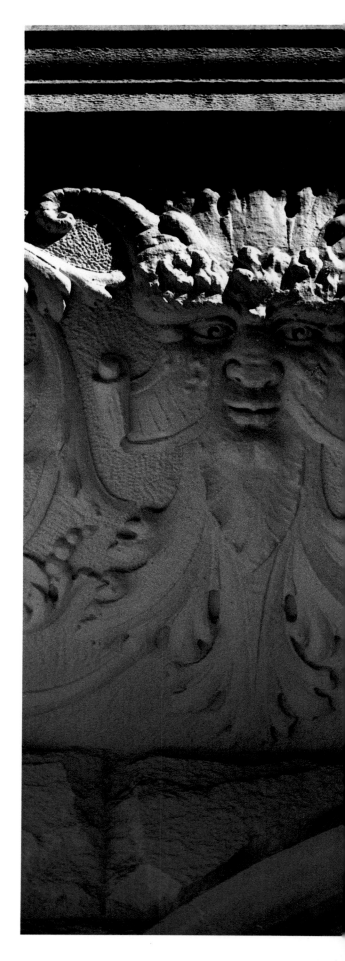

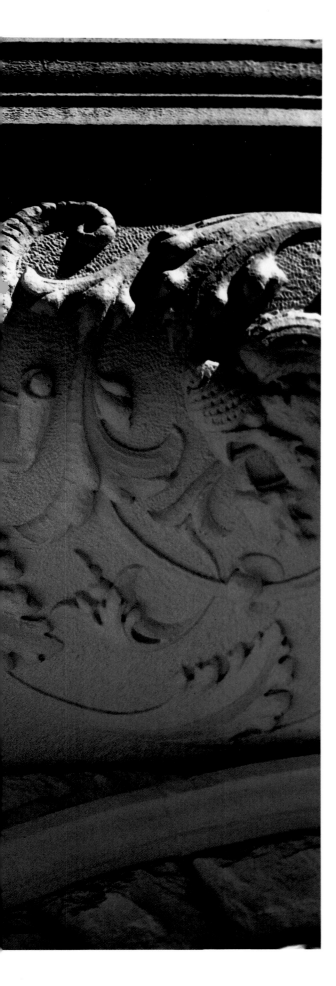

"Come into the hall," he said promptly. There were four of us at that meeting— Glimcher, his assistant, my literary agent, Kirby McCauley, and myself. Glimcher drew us across the room. There were a number of bold and dramatically lit paintings on the walls, but he ignored them in favor of a rather grimy window in a fifth-floor hallway which was what I suppose you'd call "backstage"; it led to a combined office and storage area. He placed me in front of the window exactly as a gallery dealer might place a prospective buyer in front of a painting or sculpture. In a way, he had done just that…although the sculpture he was pointing at was across the street and most definitely not for sale.

The building there had an entrance that was a keystone archway. It was the sort of building one passes every day in New York, neither old nor new, neither odd enough, beautiful enough, nor ugly enough to attract attention. Just a building.

Except for the nightmare face jutting out from the brick just above the keystone of the arch.

I think I made some sort of noise—not a gasp, but close. Glimcher smiled again. It wasn't a smug smile, or a mean smile, but one of genuine pleasure. It was the look of a man who has just shared something he has wanted to share for a long time, or who has found a kindred soul (and I'm sure he felt that way to at least some degree; one does not work on such a project as this as a business venture, but as a labor of love).

Then he said something I'll never forget, something which not only convinced me to write this essay, good or bad as it may be, but made it impossible *not* to write it. "Because they are almost always above human sightlines, and because people in the city rarely look up, they don't see…*them*," he said, gesturing to the horror across the street, the horror so strikingly at odds with the anonymous building from which it sprang, like a tumor sprouting from the mild brow of some harmless middle-aged and middle-class executive. "But *they*…well, you'll notice that they're almost always looking down." He paused, then smiled again. The smile was different this time: thoughtful, and, I think, the tiniest bit uncomfortable.

"We don't see them," he said, "but *they* see *us*."

No one said anything. We went back to Glimcher's office. I agreed to do the essay. I found I was very glad to be away from that window.

Since then I have found my mind returning to it again and again.

My *head* doesn't know much about art…but my *nerves* seem to know something about gargoyles. And I'm writing about them not for money, not to see my name in print, not even because I believe that the few things I can say will improve this book much (stacked up against the photographs to which you will soon be

exposed—that is the only fair way to put it, I think—any words of mine would be paltry things indeed), but for the same reason I have written some awful things in my books: writing is a simultaneous act of catharsis and translation, an emotional sluiceway, a method of understanding why those nerves are stirring, or why these photographs make me feel the way a bird must feel before an earthquake, knowing it must fly, but not why.

As I've suggested earlier, the act of understanding is often a kind of little death for the intuitive writer, but some things are better off dead. I don't think the images of the gargoyles in this book will ever die in my mind—even the most benign are somehow horrid and alien—but it may at least be possible to still that wind in the nerves.

He takes me to the window, small, dirty, crisscrossed with old chicken-wire, and points across the street to something which seems to be a monster being born not of a living creature but of a building. Seeing this obscene thing is a shock; what is worse is seeing the people passing to and fro beneath it, intent on either plotting their day's business or planning their evening's pleasure; they pass to and fro and do not look up.

None of them look up.

I hear him say it again: We don't see them...but they see us.

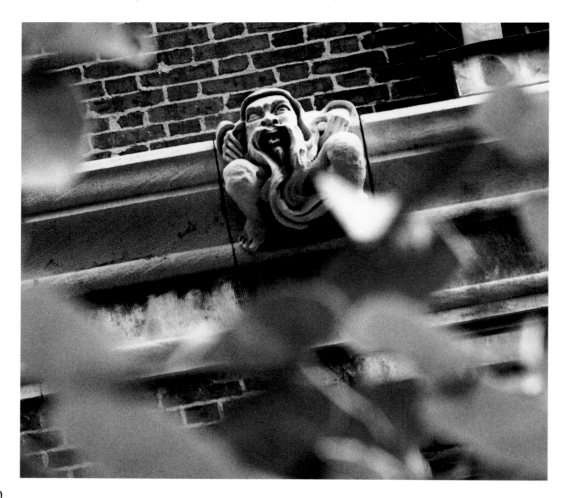

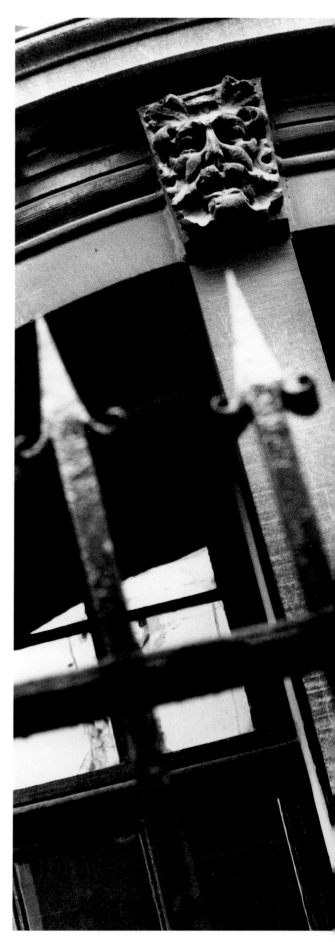

10

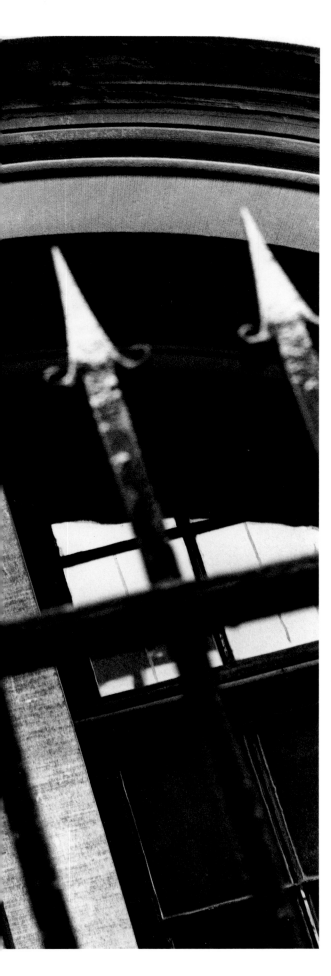

We sealed the bargain with a couple of cold beers, shook hands all around, Glimcher thanked me, I told him he better wait and see what he got before he offered any thanks, and then Kirby and I cabbed back to his office.

I kept trying to look up.

I couldn't do it, at least not without looking either very silly or very drunk.

I couldn't see *them*, but *they*...

Oh shut up, I told myself.

Well, you can tell your head to shut up all you want, and sometimes it even will deign to do so, but as Robert Stone says in *Dog Soldiers,* the mind is a monkey, and it is agile.

...*they* can see *you*, my mind finished.

My nerves stirred. I looked at the backs of my hands.

There was gooseflesh on them.

The next day I had lunch with a guy I've known ever since I started publishing—he was then a magazine editor and has since then "moved up," as they say. I told him about the essay I'd agreed to do and showed him some of the photos they'd given me to study. This was only casual waiting-for-the-appetizers conversation, and I thought we'd move onto something else quick enough, but this old friend—who I guess I'll call "Jerry," since the deadline on this piece has started to get uncomfortably close and I never *did* get around to asking him if I could use his real name (when it comes to close friends, I tread softly—I have too few not to be careful with 'em)—went nuts over the pictures, and the whole *idea*. We spent most of that lunch talking about 'goyles. I was surprised at first...and then I understood. Jerry's a bachelor, and although he both loves and appreciates women, and although he's twice in my fourteen-year association with him (God, it's awful how time gets away!) come very close to marrying, I suspect he may never do it. The woman he seems to love the most, you see, is a beautiful bitch-goddess who will whore but not wed. Her name is New York City. Jerry knows it from the Battery to the Bowery, from the petting zoo in Central Park to the human one in Washington Square where the hypes shake and wipe their noses and wait for the man.

A trip across town in a limo or a cab during rush hour usually results in a contradictory state of frazzled nerves and numbing boredom. When you have Jerry with you, you're sorry when a hole opens up in traffic and you start to move.

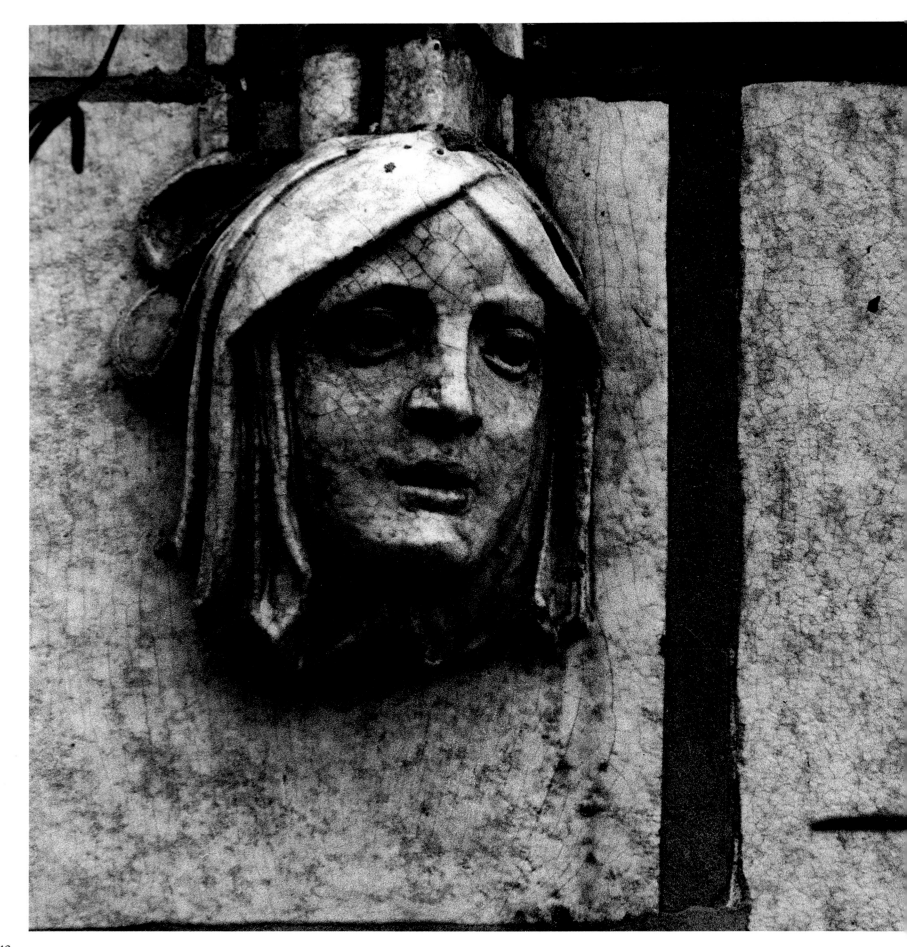

He's lived in New York all his life (i.e., he is a person who takes his passport when he has to go to Jersey), and he knows something about every building, even every corner, it seems. He can show you the place where a famous politician's aspirations crashed; the church where a godly man was finally awarded a red Cardinal's cap; the sidewalk in front of a famous steak-house where one decidedly less godly was gunned down.

And of course he knew about *them*.

The gargoyles.

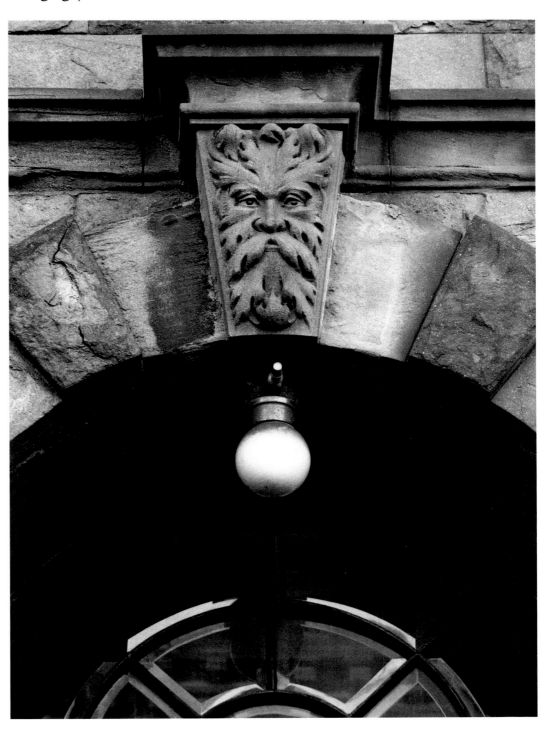

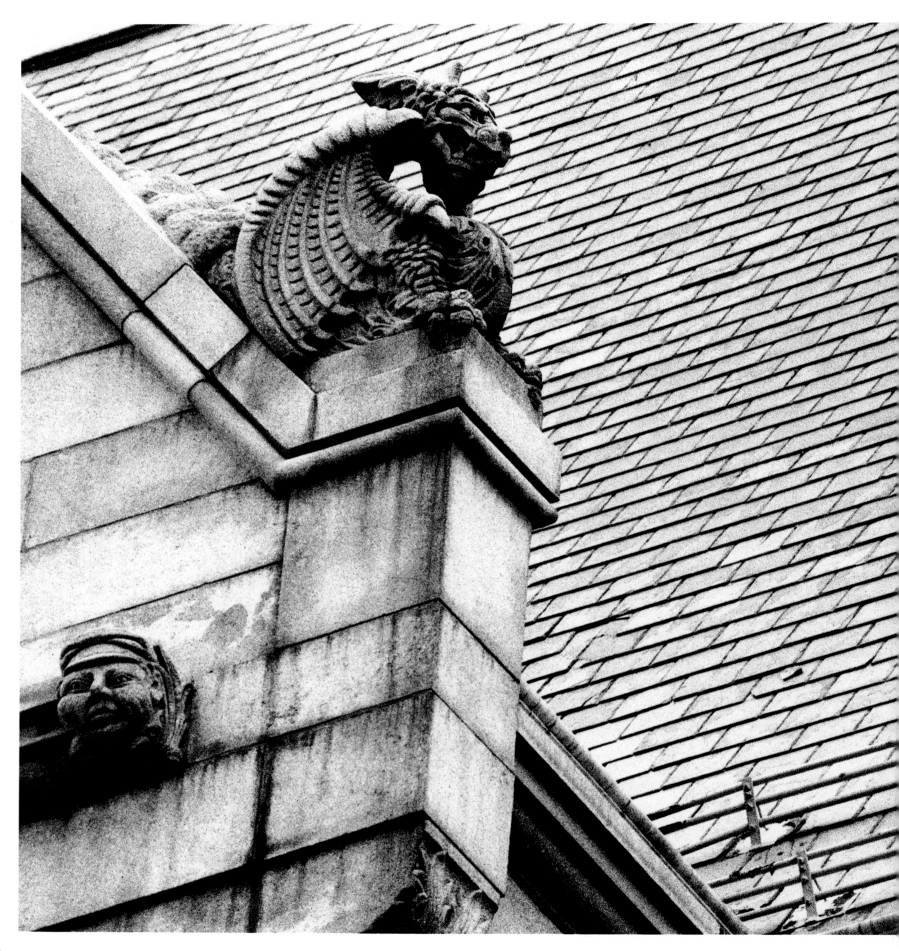

For approximately ten years, from about 1966 to 1976, the three TV networks experimented—ABC, the perennial bridesmaid in those days plunged the most heavily—in what was, for them, a radical new sort of programming. Of course, what is seen as a "radical departure" in televisionland might seem fairly tame or even stupid to the rest of us, but then, most of us work in businesses where the furthest one may be promoted is to the level of that person's incompetency. This is the Peter Principle, of course. The television industry, which believes nothing succeeds like excess, has gone that one better. In TV, when one reaches one's level of incompetency, one may look forward to at least two more promotions. If the second of these promotions shows a level of incompetence not just visible but positively massive, the individual in question may possibly be tapped to head the network.

Although as anyone with access to a computer terminal and a utilities program listing all produced talking films, cross-indexed to highlight all those available and suitable for TV exhibition could see, it apparently did not occur to television execs until fairly late in the game that the supply of celluloid was finite. This was very bad news, because the networks had come more and more to rely on movies. From the first regular network movie series (NBC's *Night at the Movies*, a "radical departure" in itself), the trend proliferated until *every* night was *some* network's "Night at the Movies," and on some of those nights, there were *two* network movies.

With their usual shrewd foresight, TV executives realized they had forgotten to replant the forest just as they were about to cut down the last few acres of trees. Delirious at having discovered a product which, having been pre-produced at no risk to themselves, was almost pure profit (after all, both movies and cars get cheaper as the years pass), they did not realize that the Nielsen ratings on their movies were dropping because they were scraping the bottom of the barrel. By the time some whiz-kid came up with the concept of made-for-TV movies—B-pictures made on series TV budgets—the networks had almost no choice; they were down to karate flicks and movies about kids driving around in dune-buggies.

A few good films came out of the made-for-TV era (a side-note: the first, *The Killers*, was made for NBC, which refused to air it because of its violence—it starred Lee Marvin, and, in his last acting role, that old chimp-lover, Ronald Reagan), but most of them ranged from the humdrum to the almost hilariously bad.

One of the latter was called *Gargoyles*. This was standard ABC-TV "Movie of the Week" fare, made in about ten days on a low budget. The results were

low-budget, too. In the useful tubeside companion, *Movies on TV* (edited by Steven H. Scheuer; individual ratings and capsule reviews not credited), the film is given one star, defined as "poor." Starring Cornel Wilde, written by Cornel Wilde, and directed by Cornel Wilde, Scheuer's guide describes it this way: "Laughs rather than thrills accompany this lousy 'horror' film. Anthropologist Wilde faces legendary gargoyles, busy hatching 500-year-old eggs in the Carlsbad Caverns." The reviewer, one feels, wanted to add that Wilde was a faster worker: it took him less than two weeks to hatch *his* egg.

This review is right.

This review is wrong.

My *head* recognized the film for the ninety-minute turkey it was when I first saw it, but my *heart*—no, strike that; not my heart but my *nerve-endings*—recognized something else, something far more important: it was scaring the shit out of me in spite of how bad it was. Some of it had to do with Wilde's one canny decision: to film the gargoyles themselves with low-light film in slow-motion, then to "polarize" the footage...in effect, turning these shots into color negatives. You can probably do the same thing with your video camera, if you've bought one within the last year or so.

I don't think Wilde's decision to do it this way was an artistic one. Although I'm willing to give him the benefit of the doubt, it seems more likely that it was a way of giving some spurious realism to gargoyle costumes so clearly fake that they were funny (like the abominable snowman in *Shriek of the Mutilated*, which is quite clearly a small young man in a large fur coat; the circles of lampblack around this young man's eyes as he chases one victim with a baseball bat do not make him look any more like an abominable snowman, but it *does* offer the bemused viewer an interesting image: a pinch-hitter in a fur coat).

Gargoyles aired on ABC in 1972, in the made-for-TV-movie's heyday; you could have James Brolin running from killer attack dogs in a deserted department store one night, a sensitive tale of a boy and his hot-rod the next, George Kennedy tying himself to a post in his backyard because he's afraid he's got rabies and might bite his little girl and infect her the night after that.

And, of course, the gargoyles hatching in the Carlsbad Caverns.

I should have forgotten it almost at once, because it was the sort of movie which seems almost *made* for that purpose, as cotton candy is spun to web away to no more than a slightly oversweet after-taste the second after you put it in your mouth, as I have forgotten the name of the boy who played the kid trying to build a hot-rod from scratch (Robby Benson, maybe?).

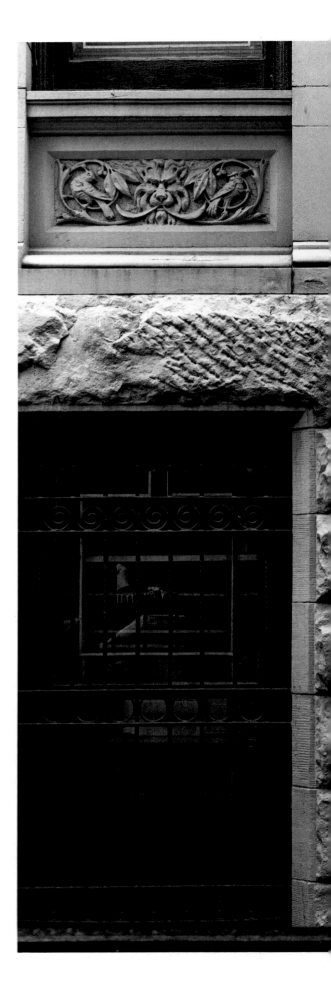

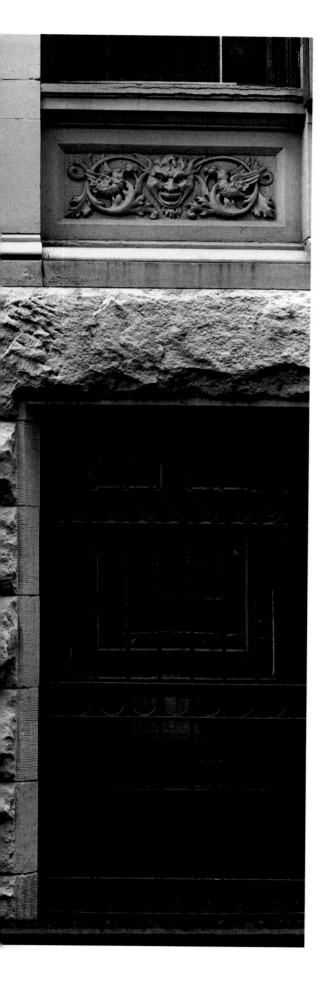

I haven't for two reasons. The first is that my head is in some way an odd trash-compactor of cultural garbage. I'm notorious for missing dental appointments, and once a pair of polite ladies had to come and get me for a speaking gig I'd agreed to do (they informed me that a hundred and fifty kids had been waiting for half an hour...and they passed me this information while I was crashed out in front of the TV in my office, drinking beer and watching a movie on TV, dressed in jeans and a t-shirt) and then forgotten...but for some reason I can still remember it was James Brolin, who used to play second banana to Robert Young on the show I used to call *Mucous Welby, M.D.*, in the movie about the attack dogs.

The second reason is that the movie was genuinely disturbing. Disturbing enough so that, when I bought a video cassette recorder some two and a half years later (a machine so heavy and primitive that to call it a prototype was almost being too kind), one of the first things I taped was *Gargoyles*, when it showed up on a Saturday afternoon movie.

My son, who would have then been all of two and a half, watched as I taped it...and had nightmares that night. The next day he wanted to watch the movie again. I believe if my wife had been there, she would have forbade it and would have looked at me as if I were crazy if I even showed signs of considering it. But she was visiting, and so I *did* consider it, deciding that maybe it would be worse therapy to withhold it, thus allowing those gargoyles (which really *were* pretty ridiculous, once you got over the original shock) to grow from a single weed or two in his head to an overgrown mental garden of them. So I ran it, and we *both* watched.

Fascinated.

Again.

I don't know if I was right or if I was only lucky, but there were no more nightmares. Over the next three or four years, I think Joe must have watched that sick puppy of a movie half a dozen times...and more often than not, I ended up watching it with him. We got so we could quote the lines at each other, or I'd ask Joe to get me a glass of milk (by age four he was capable of pouring the milk into the glass instead of all over the counter at least three times out of every five) and he'd say, "Sure, dad, just wait 'til the 'goyles almost get the girl in the parking lot, okay?"

'Goyles. That's what they were and still are to Joe, who is now almost fifteen (and who gets the milk in the glass at least eight times out of ten, maybe nine). 'Goyles. Like what kids from Brooklyn go to dances to meet, don't you know.

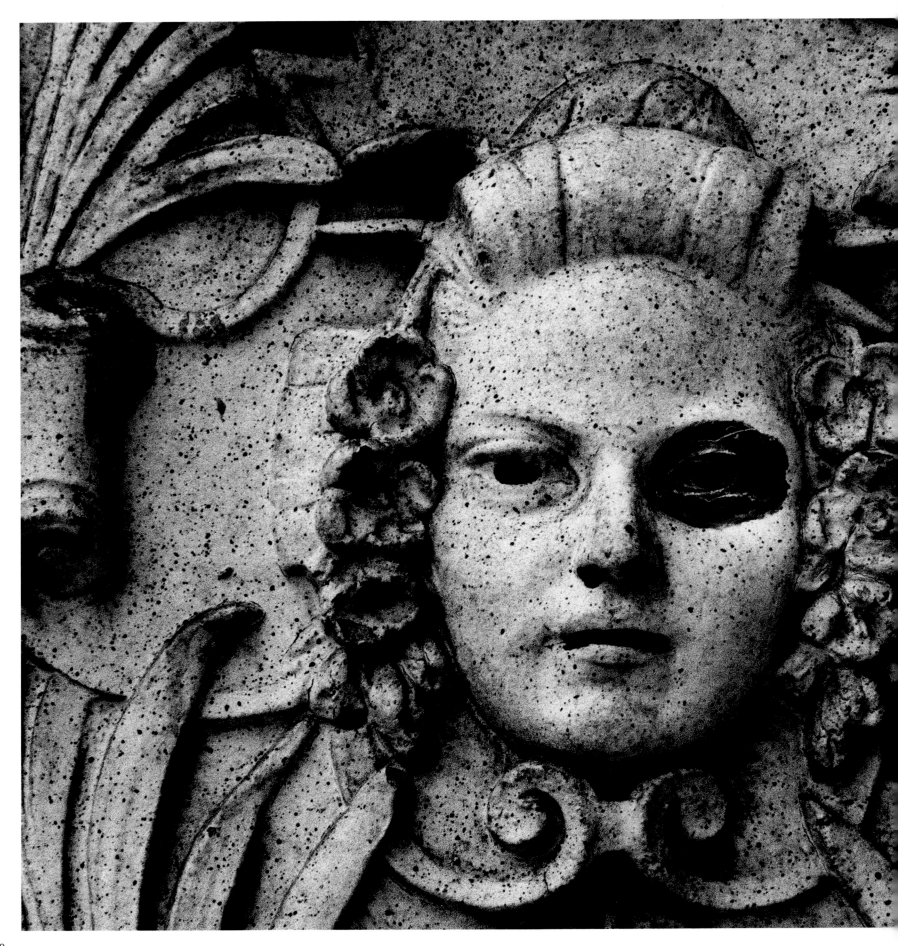

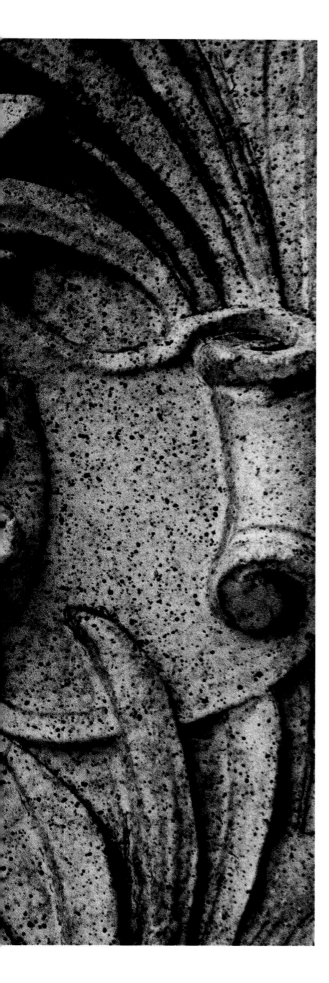

At lunch with Jerry that day (I remember it not only because of our talk about the 'goyles but because it was the first time—and will probably be the last—that I ever beat him to the check…but since he left publishing, Jer's reflexes seem to have slowed a tad), gargoyles were all we talked about…or rather, Jerry talked and I listened. Listened while he told me there are 'goyles on the cornices of the Helmsley Building and neighboring Grand Central Station; not just on the cornices, in back, but over the entrances as well. He told me there were gargoyles on almost every church in New York, Protestant, Catholic, you name it. He told me that one can take a Circle Line ferry-ride around Manhattan Island and see stone demons peering out from the overgrown foliage which overhangs the Hudson River on the uptown shore. There are, he told me, gargoyles on a madhouse that has been deserted for sixty years or more, and is now crumbling into an overgrown piece of ground that has been in litigation since forever.

So when he asked me if I'd like to have some dessert, I told him I'd take a raincheck. I'd gotten to thinking about that movie, you see, and how it managed to find all the right nerves in spite of how bad it was, and those thoughts merged with the photographs I had been looking at, and all of these things were overlain by Glimcher's voice, saying: *We don't see* them, *but they see* us.

I thought *I* might be the one having the nightmares that night.

And maybe for just that reason (which really wasn't much different from my reason for allowing Joe to see the movie a second time), I declined dessert and asked him if there was any one street in midtown which he thought was particularly rich in gargoyles.

"Madison Avenue," he said promptly, and so I asked the driver to take me to Madison and 29th.

When I got out, the cabbie asked me what gargoyles were.

"Nightmares in the sky," I said, and tipped him an extra buck. Once it was safely in his pocket he offered the opinion that everyone in the city was fuckin' crazy and took off in a hurry.

I'm not much of an exercise freak; in an era where it seems that everyone who isn't "going for the burn" with Jane Fonda is jogging from noplace to noplace in their Reeboks, Spaulding headbands, and Jordache running shorts, all I do is walk. But I walk a lot. It's good for your cardiovascular system, and it doesn't smash the pads of cartilage in the knees flat as jogging does after ten or twelve years of it. It has one drawback, however: it's boring as hell. Which is why, when I go for a walk, I always bring a book along. All those people you see in the city

walking or jogging with Walkman phones on their ears? I know where they could put 'em, but they'd have to stop and bend over to get the job done.

Anyhow, I had a book with me that day, not because I had been planning a walk but because of another of those little laws related to the Peter Principle (in fact I believe that such little principles of human life—the only time you can never find matching socks is when you're in a hurry, when you're flying the turbulence never starts until the coffee's been served, etc.—are now called Peter-isms). I call this one (he said modestly) King's Theorem: If you have a book with you to pass the time, everything will go on schedule. So I had the book, but I walked all the way from Madison and 29th to my hotel at Fifth and 59th without opening it once...without even thinking about it, in fact.

When I woke up the next morning with a neck so stiff it was agony to turn my head much more than ten degrees to one side or the other, I realized I was suffering from the same thing that had afflicted me for about a week in 1975. In that case I had unwisely stopped to pick up a hitchhiker and had been violently rear-ended by a delivery truck. Following the accident, I felt fine. The next day...whiplash. It wore off a little more quickly after my gargoyle-hunt up Madison Avenue, and I didn't need a doctor to tell me how I had come by it; I had walked thirty blocks with my neck craned back.

I had been looking at those nightmares in the sky.

There weren't just a few of them on each block—and maybe some blocks there were none at all; but it seemed to me then that there must have been *thousands* of them, but that was, I suppose, only a subjective feeling caused by my shock of awareness—I was seeing them for the first time.

Two months prior to this writing, which is to say in February of 1987, I asked Kirby McCauley, my agent, if he thought there was a particularly "good" street for gargoyle-watching. He's not a native New Yorker, hasn't lived there long enough to take his passport with him when he goes to New Jersey (but I bet ya reach for it, Kirby, ha-ha!), but *has* been there long enough to know the city well. His reply was as prompt as Jerry's: 83rd Street, he said. So I hired a limousine with a sun-roof and cruised the entire length of 83rd with a pad on my knee and a pencil in my hand. Magnanimous fellow that I am, I didn't even charge Pace (if I had, they probably would have sent the bill back with their own ha-ha! stamped across the face of it). I counted up my hash-marks and made the total a hundred and one.

Jerry had been right; the funny thing was, Kirby was, too. The truth is, New York seems nearly *overrun* with those nightmarish things. In both cases I probably counted in some sculptures which, technically speaking, are not gargoyles, and

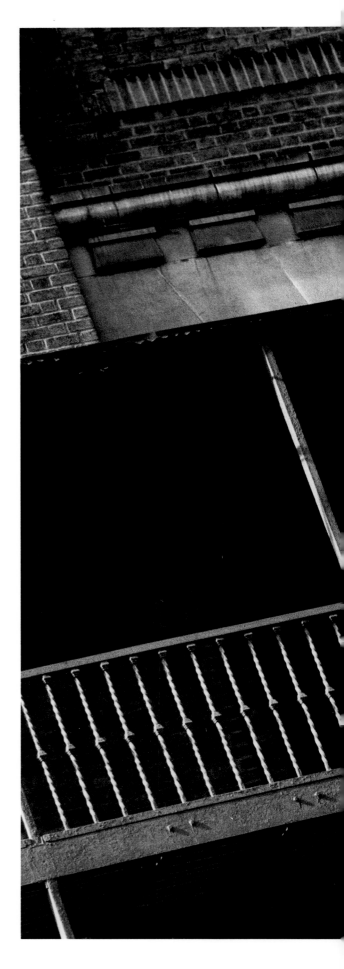

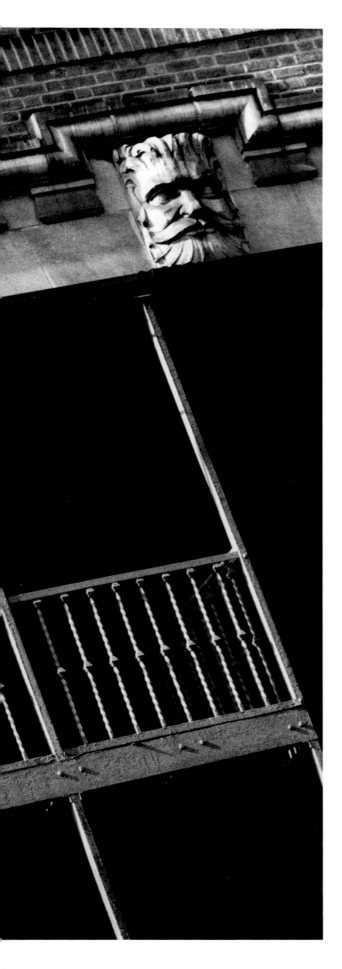

counted out some which, speaking the same way, are.

But, goddam! There seemed to be so *many*! On impulse, I had the driver take me down Madison again, and although I didn't count, I could almost swear there were *less* along that thirty-block stretch than when I walked it the first time.

Of course there weren't. Illogical, as Mr. Spock would say.

But the mind is a monkey...and mine keeps trying to think that there really *were* thousands that first time, and most of them either hid or flew away when they saw me coming back for a second look.

It's utterly ridiculous of course, but suppose...

Well, suppose they don't like people watching them?

Suppose they only leave the ones that have somehow "died"—and God knows, the ones you see are disturbing enough to wonder, if they're the *dead* ones, what the live ones look like. But isn't that what we're really afraid of? That a really close examination will prove our worst nightmares to be reality? *That those monstrosities are alive?*

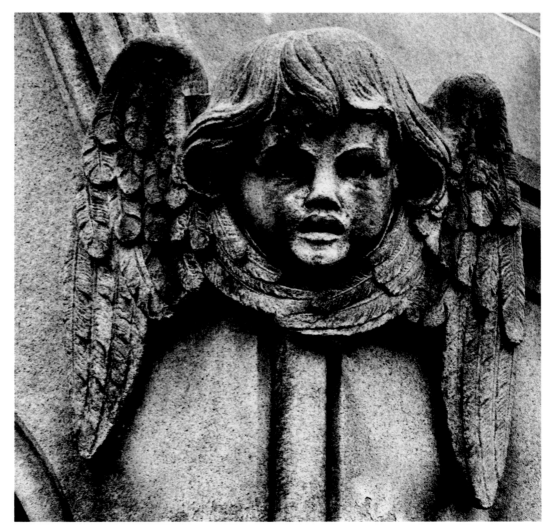

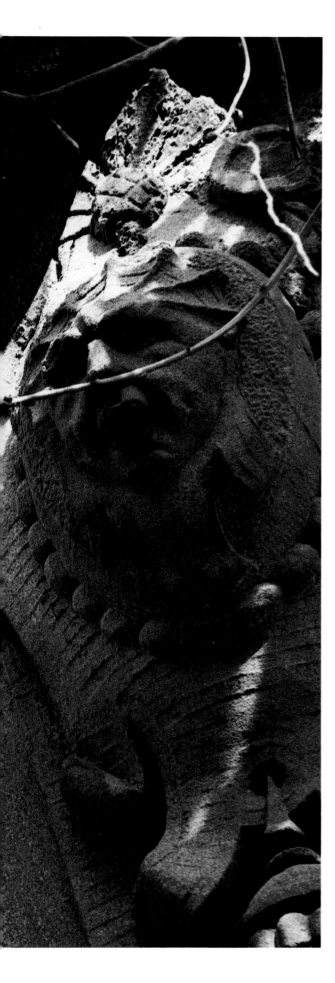

Before sitting down to write this essay, non-technical as it is, I *did* do one piece of necessary homework: I studied each of the photographs being considered for the book carefully. There were hundreds, and the final selection is still being made. You'll not see all of them, and not all those you do see will be the gargoyles of New York (good God, it sounds like the name of a *Playboy* pictorial). But I believe you'll come away having drawn the same conclusion I have. My intuition was not in the least ridiculous. They *are* alive. They may not actually fly off the buildings they adorn (in *Burn, Witch, Burn,* a much better film than *Gargoyles,* one does exactly that—it is a hideous sequence which, once seen, can never be forgotten) or hide behind their soot-blackened towers and chimneys when those aware of their presence pass below, but they are, nonetheless, alive.

The most nightmarish thing about the gallery of stone nightmare faces in this book is that, stone or not, pocked and eroded by time and pollution or not, spray-painted by vandals or not...*they are alive.* It is simply impossible to look at these pictures and believe anything else.

This sort of book, you know, is called a "coffee-table book" in the trade; one of those truly beautiful objects one leaves out to either decorate a room or to try and impress others with one's superior tastes...depending on whether the book's owner is a genuine lover of fine books or just a snot with cultural aspirations.

Coffee-table book or not, I would suggest a coffee-table might be the worst place for this particular tome; coffee-tables, after all, are low pieces of furniture, accessible to children, and I am as serious as I can be when I say that this is no more a book for children than George Romero's *The Night of the Living Dead* is a movie for them. The faces the viewer looks upon as he or she turns these pages are not the faces of Cornel Wilde gargoyles, actors in bad costumes who have only been rendered marginally real by technical hocus-pocus; these are not Latex masks which can be pulled off when the shooting is done.

They are real. They are alive.

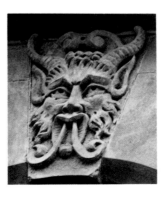

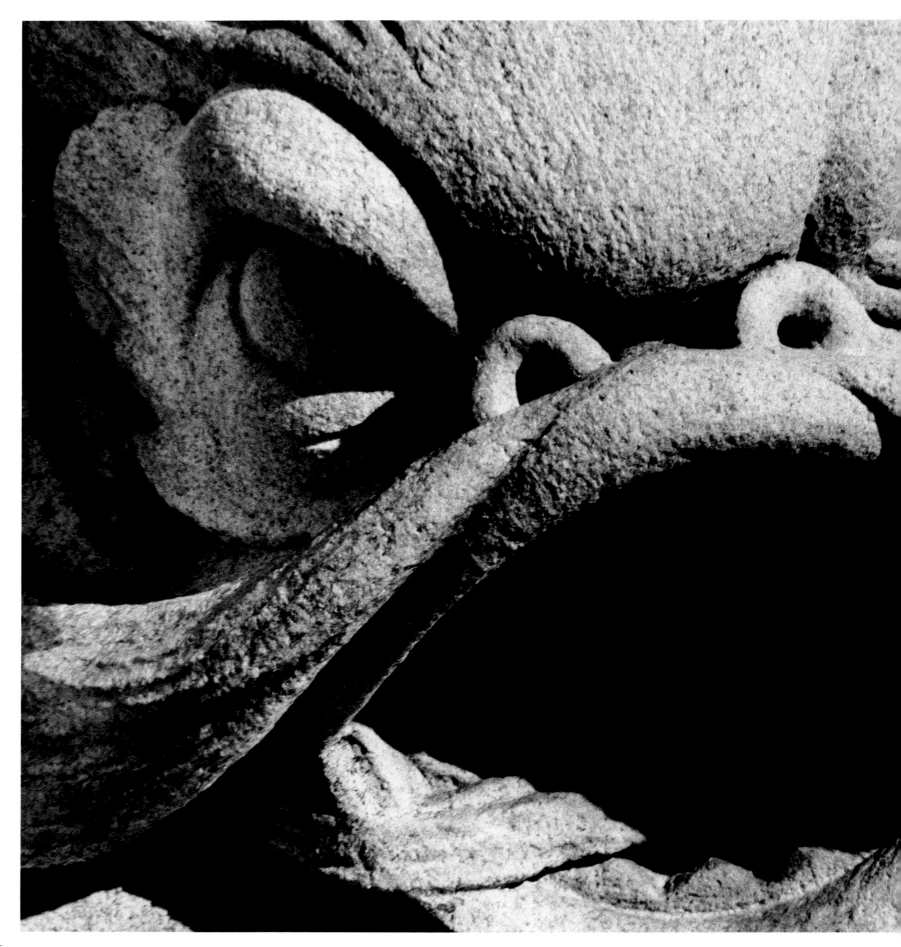

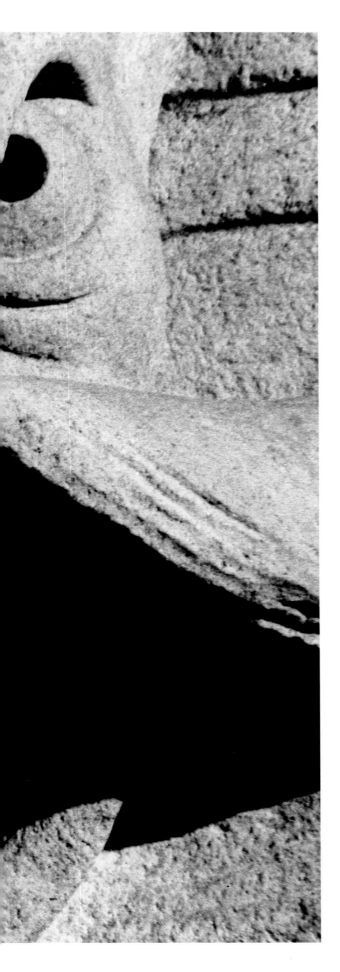

There might be people out there scanning these words and thinking, "He means that in a figurative sense, of course. He must. Because anyone who really thought stone gargoyles are alive...well, that would be a guy long overdue for a little rest-cure at the neighborhood funny-farm."

But I *do* believe they are alive—*know* they are, in fact, and am in complete possession of my faculties (ask any lunatic and he'll tell you the same thing, heh-heh-heh). I began by saying I had very little technical education in the field of art, wanting to play fair with the reader and to explain why I could not simply stride up to my subject and collar it but would, instead, have to approach it in careful sideways hops. An objective a man armed with knowledge may take boldly, by frontal assault, a man armed only with intuition must take by guile, if he is to take it at all.

However narrow my technical knowledge of art may be, however great or small my ability to create it in my own field may be, I am not a culturally disenfranchised man, and I have tried to approach any creatively "made thing" with an open eye and mind—book, film, photograph, painting, sculpture.

Because I write fiction, my job depends upon my imagination. Imagination, in turn, depends upon that wide eye, that interested, examining, unprejudiced stare which may eventually judge but which comes to its subject utterly without preconceptions—only the hope one will see success rather than failure, not for any altruistic reason but for a sublimely selfish one: a creatively "made thing" inspires the person exposed to it with a clear sense of wonder and joy...and, looking at these gargoyles, I felt those things just as surely as I felt horror and a revulsion so immediate that it was almost instinctive...the way that some people feel about snakes, the way I feel only about bats and spiders.

A piece of sculpture, be it a sculpture by Rodin or one of those nameless stone horrors peering through the overgrown trashwood on the banks of the Hudson River, is not alive in any physical sense; it does not breathe, bleed, or, in spite of my imagination, fly away or hide behind the chimneys (I don't *think* so, anyway, although I could *swear* there were less of them when I...oh, never mind).

But the sky does not breathe, bleed, or hide behind chimneys, and yet we may say it is alive because it changes constantly. Not only is it different from one day to the next, but it may be different from one moment to the next, depending on our own moods, which, being alive, are in their own constant state of flux. We may not look at the sky as often as adults as we did as children, staring at it with that wide eye of total open-mindedness—that eye which is the wellspring of wonder and thus the doorway to imagination—but we *do* continue to look at it, and even

hurrying to work, minds busy ordering the business of the day, perhaps late, that last cup of coffee burning acidic in the stomach, we may stop, all else forgotten, momentarily transfixed by a configuration of clouds that looks exactly like a pair of frightened, running horses being pursued by a bull.

Give a child a kaleidoscope and he or she may sit for as long as an hour, transfixed, turning the tube and watching the patterns inside shift and change, shift and change. Adults are supposed to have longer attention-spans than children, and yet they rarely have time for more than a quick glance...although I think you'd find that almost any adult left in a room with a kaleidoscope would pick it up and turn it for awhile, watching those changing patterns as avidly as the child, and if that same adult should enter a room where there happened to be a large conch shell sitting on a shelf, he or she would be more apt than not to pick it up and put it to his or her ear, listening for what our intellects know is only the slow vibration of air in an object curved in such a way that it becomes a natural echo chamber...

...and what our hearts know to be the sound of the ocean.

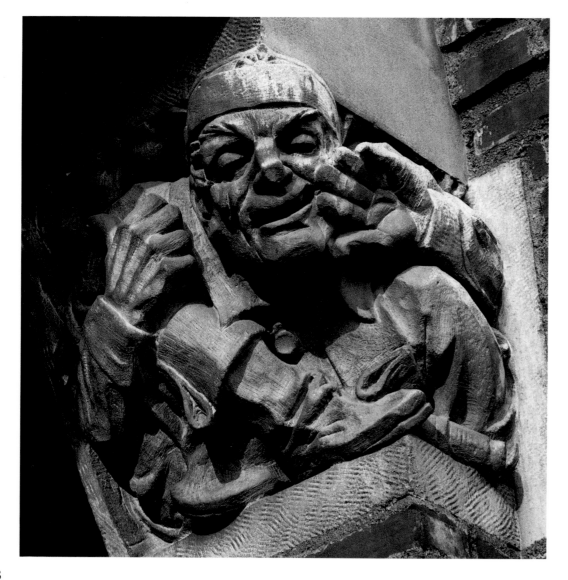

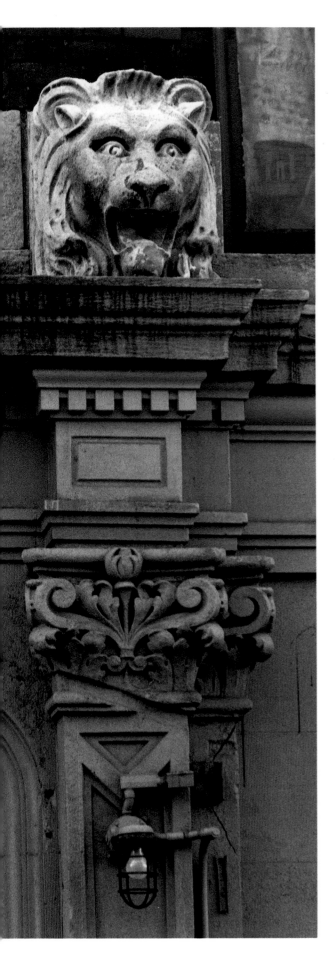

My wife has a Tiffany vase. She keeps it in a glass cupboard in the small entryway between our dining room and her study. I have just now risked her wrath by going downstairs and bringing it up here to my study. It is standing to the left of my word-processor as I write. This is not something from the T'ang Dynasty, not a Picasso sculpture, not a Van Gogh painting. It is, I suppose, vulgar art beside such things. Yet it *is* art, because it *does* change…as only live things do. I am going to stop here and look at this vase for three minutes or so. But don't worry; you won't notice the time-lag at all.

Okay. My wife's Tiffany vase.

It's blue, with white flowers and vines on it.

Doesn't sound like much, huh?

But the blue is a shade and texture I cannot precisely describe. It has a metallic sheen which should make it look harsh and cheap but instead gives it a sleek and satiny look that makes you want to touch it…and when you do, your palm is surprised by the contrast between the smoothness you *thought* you'd feel (and which *is* there) and the raised texture of those white flowers, which have been hand-painted. I touched it, and since beginning this paragraph I have paused to touch it twice again, partly to get this as right as I can, but mostly because I wanted to: the feeling is startlingly sensual. The rise of those flowers against the sleekness of the surface, coming as they do on the swelling near the top of the vase, made me think at once of how it is to cup a breast, with the hard little bud of nipple at its tip. Eventually, touch is not enough. That sexy contrast of smooth and rough makes you want to stroke.

Inside, one sees darker veins of blue twisting into the dimness of the thing; if it is held at the right angle to the light, one can see these darker veins form a tracework of startling delicacy. The vines on the surface are a dark green which should go badly with the blue and which is, instead, simply perfect. I am looking at a wonderful "made thing," and if and when I find the courage necessary to take this wonderful thing back to my wife's cabinet again (and it *does* take a certain amount of courage; for the third time, the mind is a monkey, and it is all too easy for me to see it slipping from my hands and lying on the floor in fragments), I expect to see something different. It would not change to suit me; that's the pathetic fallacy English majors are warned about in very short order (usually during their first comp class—all that shit about how the sky is weeping is just that: shit). It would change to suit my eye, perhaps—a little—but mostly it would change because it is alive, and change is the essence of life.

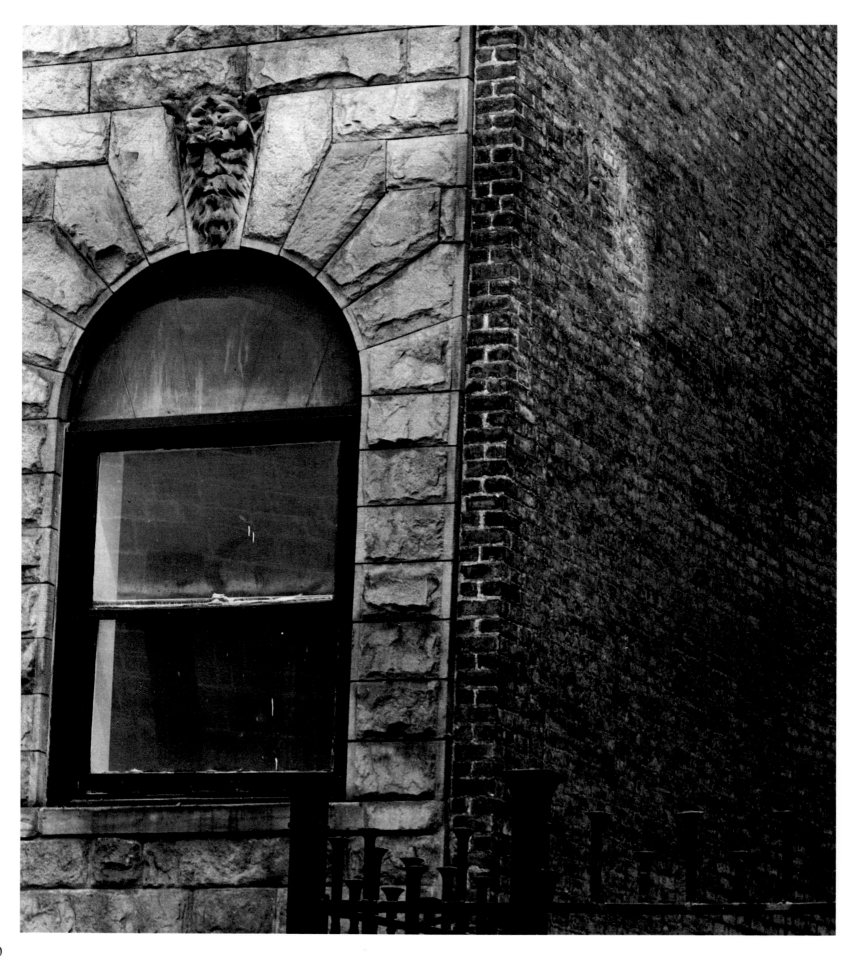

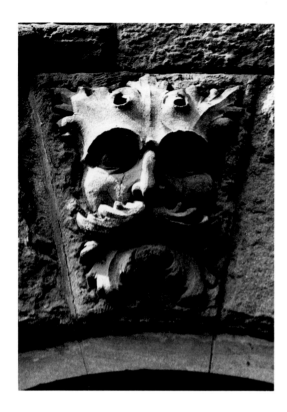

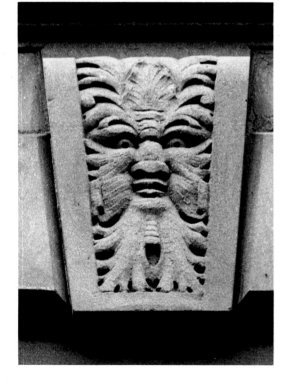

For the student, the academic, or the artist who is able to approach his or her work intellectually as well as emotionally, the question as regards the images in this book may be: *If they are alive, how were they made so? How is this particular effect which changes in its specifics, but seems to maintain a constant emotional key-chord of fear, even horror, achieved? What are the common elements which cause revulsion and fascination to balance so perfectly?*

For someone who is aware of a life-force strong enough to carry over into the *images* of the objects as well as the objects themselves, the questions are more practical ones: *How should I deal with these things? What are they for? Is there something I can do with them?* The answers to the first two will depend on the individual; the answer to the last *must* be yes, or it isn't art we're dealing with after all, but immoral things—and the real objection the thoughtful person has to immorality is not that an immoral thing is evil or pornographic but that it is a stupid thing, a useless thing, and not a live thing after all, but only dead weight, good for ballast but not much more.

Moral things serve a purpose, and this is true of gargoyles even on the most mundane level. I told you I would not research this subject; that since the decision to write the essay came from my nerve-endings in the first place, I would write it from there. But the act of writing has always been a form of self-hypnosis for me, and once the initial oddity and awkwardness have worn off (sitting down at this machine is a little like having to re-learn how to ride a bike every morning of your life), I'm a little bit like a guy wandering through an old museum, opening doors with rusty hinges to see perfectly preserved things inside, mostly useless, but still there.

Perfectly preserved? Well, I guess that's an exaggeration. I had two years of Latin in high school, and I suddenly remembered that the first gargoyles were nothing but fancy gutters, and that the word comes from a Latin one meaning either "drain" or "gutter" or "gullet." I suspect it's the first, but I'd rather believe it's the last. Not just because the words sound a little bit alike, but because the sound is the *right* one; rough, hoarse, and unpleasant. And, I think (again, the urge to look this stuff up is very strong, the wanting to make sure I'm not barking up the wrong tree), they became a sort of "craze" in the fourteenth or fifteenth century, with rich folks and rich churches (the medieval late Renaissance equivalent of *The 700 Club,* so to speak) competing to own the biggest, best, and most rococo gargoyles. Must keep up with the Joneses, you know. So they hired the best artists they could find to do them up some really boss gargoyles. Because the best artists were, by and large, also the poorest artists (a state of affairs that doesn't change a

whole lot from one generation to the next), most of them took the assignments. After all, even the best artists have to eat. But they weren't too crazy about giving their best to creating a bunch of things which were, beneath the fancy icing, nothing but a bunch of pipes to drain rainwater. Artists are quite good at finding sly means of revenge, however, and if my memory really *is* correct, many of these fellows got theirs by turning the gargoyles into hideous caricatures of the very men who had paid them to create the gargoyles. If so, I don't really blame them. Suppose you were a great poet with a wife and a kid on the verge of dying of malnutrition, and some Jay Gould type offered you ten thousand bucks to decorate the plain white wallpaper of his bathroom…with your own original poems, on condition that they must be written in your own hand, and never reprinted anywhere? Under such circumstances, might you not be tempted to write a few sarcastic japes in iambic pentameter, japes just a little too sophisticated for your patron to understand? Not in the spirit of revenge, but just to salvage a little of your own self-respect?

Well, that may not be the right story, but as the saying goes, if it ain't true, it *oughtta* be. And it *feels* right, somehow. What, after all, comes more naturally to human beings than turning simple necessities into status symbols? Drainpipes become gargoyles spitting dirty water from between fanged jaws, the porcelain disposal units into which we evacuate our waste become "thrones" (the ultimate in the toilet-as-throne craze is, I think, the one you can get with the Lucite ring into which all sorts of coins and bills have been embedded, so you can take a shit while your ass is resting on approximately a hundred dollars in various types of currency), beds into symbols of taste and/or wealth.

And yet the origin of the beast is enlightening, because it points directly toward the purpose of the art-form. A drain is a perfectly utilitarian device for venting waste-water; gargoyles, with their dreamlike, hideous array of faces, may well

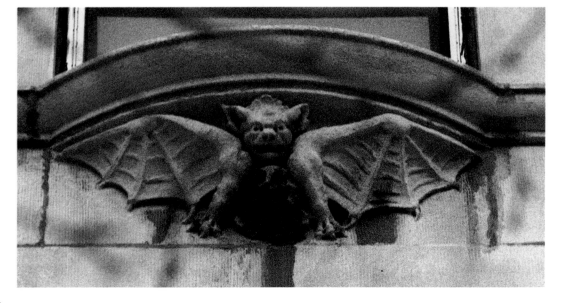

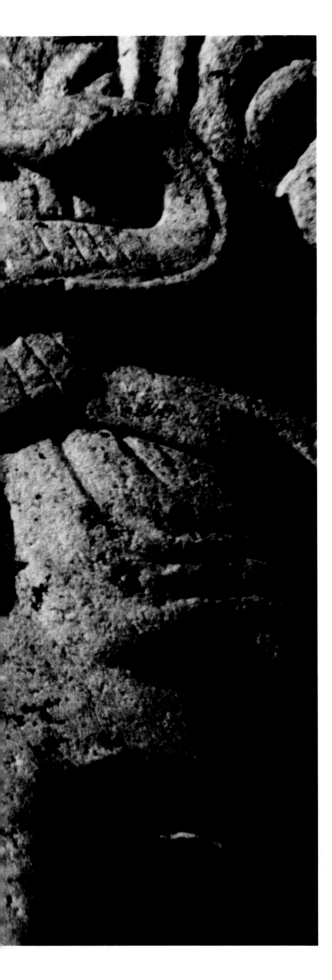

serve much the same purpose for our minds: as a way of venting the mental waste material made up of our hidden fears, inadequacies, and even our unrealized and mostly unacknowledged aggressions (you might note, as you leaf through these pages, how many of these beasts are seemingly insane with rage).

I have written a number of so-called "horror novels" in an effort to articulate some of these fears and aggressions, feeling (and, again, it *is* feeling, the logic of the nerve-endings rather than the forebrain) that expression is the first step toward understanding, and understanding is the only path to reconciling the brave and heroic people we'd like to be with the psychopathic impulses and craven tendencies that live inside in spite of all we do to root them out.

I can't say I speak for "most people" (whoever *they* are), but I suspect I'm not alone when I say that, if asked during a word-association test to respond to the word *gargoyle*, the word I'd spit out, given no time to think, wouldn't be "monster" or "statue"; it would be *Medusa*. This is also rather ironic, because the lady with the snaky hair-do is probably more famous for turning folks to stone than she is for becoming a piece of sculpture herself...which she did. Medusa, a creature too horrible for mortals to look upon, offers at least this cold comfort: in the end, she was too horrible to look at herself. She, that queen of nightmares with her writhing crown of snakes, became the world's first real gargoyle.

But go back a second. Living, Medusa turned men from flesh to stone—prototype gargoyles, one must surely suppose, with faces stretched into goblin grimaces of horror. Faced with her own reflection, she became a stone monstrosity (her mouth open in a shriek from which dirty water might pour during rainy spells, one may also suppose), one which living men might look upon with no fear of their lives...but not without fear for their sleep at least...and, at most, their sanity.

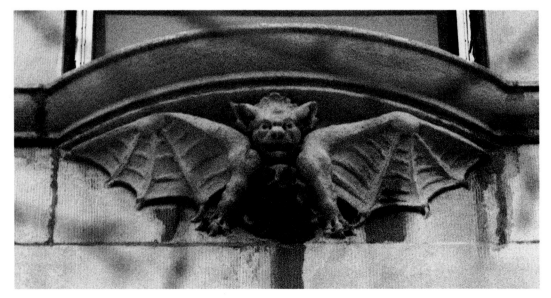

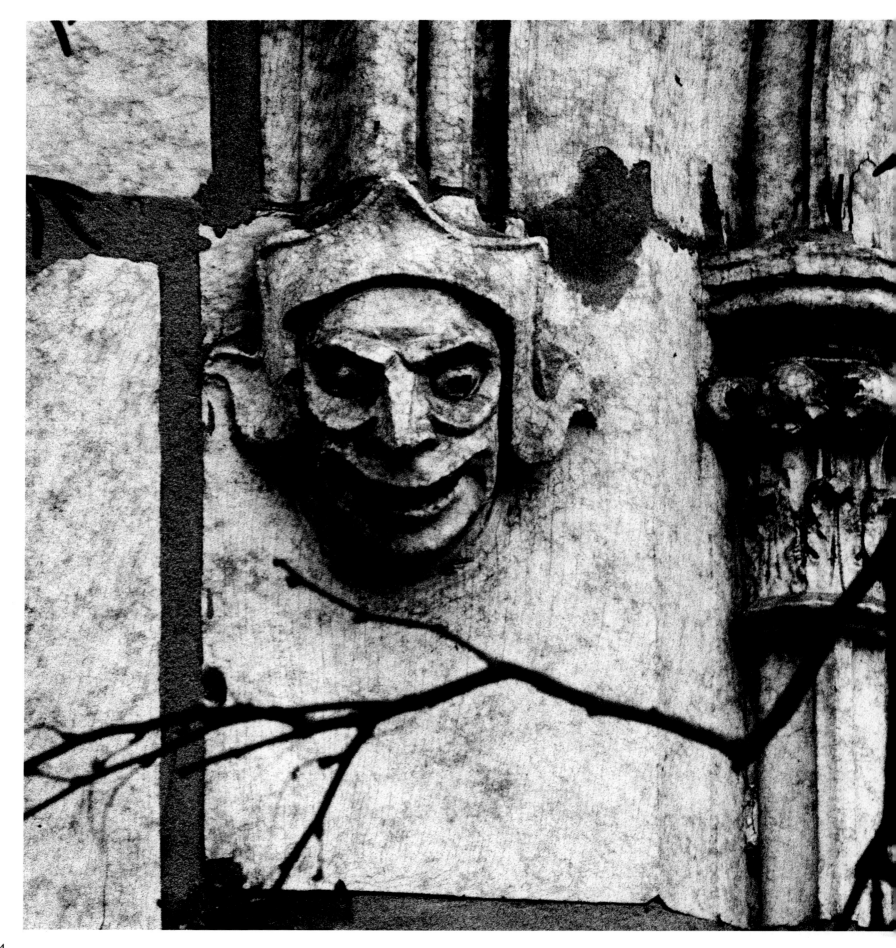

I am suggesting that the gargoyles you will come upon in this book may continue to perform their original function: to drain away that which might otherwise cause rot and erosion. Their horrible, stony faces offer a unique catharsis; when we look upon them and shudder, we create the exact reversal of the Medusa myth: we are not flesh turned to stone, but flesh proving it is flesh still, if only by the bumps that cool flush of fear always produces. It is not too much to say that great art, no matter how primitive, constantly recreates the imagination, and keeps it from turning to stone.

Epiphany is not what I'm talking about. If you want epiphany, which is (at least, as I understand it) a kind of magic communion of emotion, and if you find it here, please stay away from me. I am talking rather about catharsis, a connection less magical and delicate but a good deal more practical. English profs are apt to speak with equal reverence about both, epiphany and catharsis, but in my own mind there is nothing pretty about real catharsis. It is a painful meeting in which a human being is emotionally overwhelmed by some sort of art—brutalized by it, almost raped (and that is why the most cathartic art is almost always the most primitive)—but who emerges better for that invasion. There is nothing pretty about having your stomach pumped or pissing into a catheter, or having a doctor put a drain into an impacted cyst to drain off the laudable pus.

Not pretty…but useful.

The photos you will now look upon are undoubtedly the work of artists; yet the subjects, even those meant to look benign, are unspeakably alien, faces which will haunt you when the lights are out.

But their power is undeniable, and I think their function is just as it was before someone started the race to see who could gussy them up the most: they are dark throats, dark gullets, dark drains from which accumulated muck may spew…and thus be dissipated.

Look closely, because we see these ominous *lares* of the human psyche so seldom. They are there, these nightmares, but they are in the sky. Look closely, because even when you don't see them…

…*they are watching you.*

Stephen King
Bangor, Maine

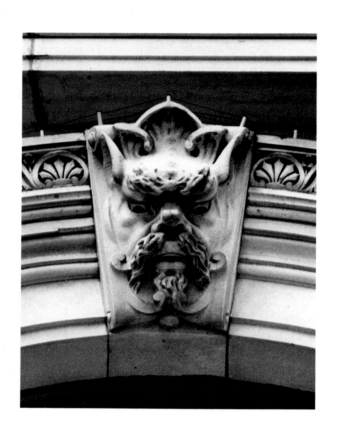

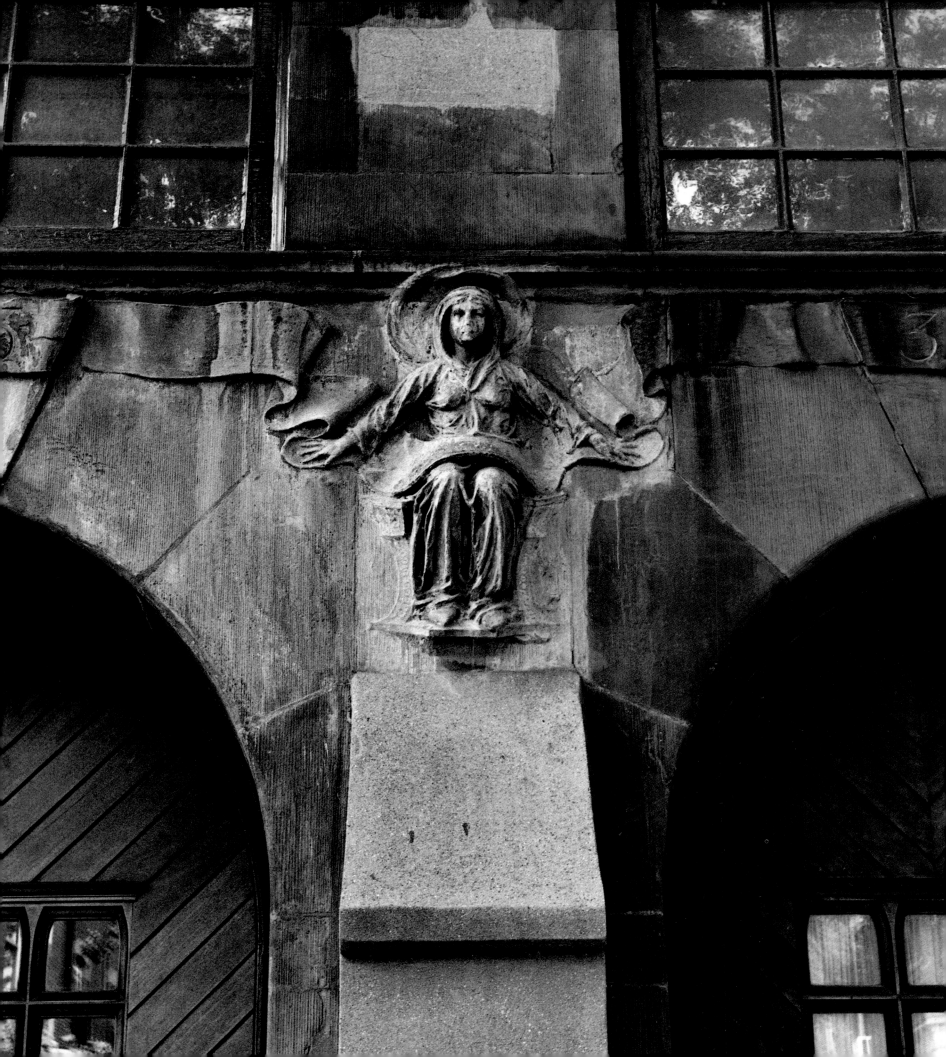

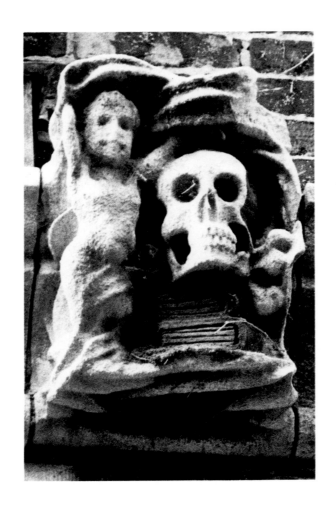

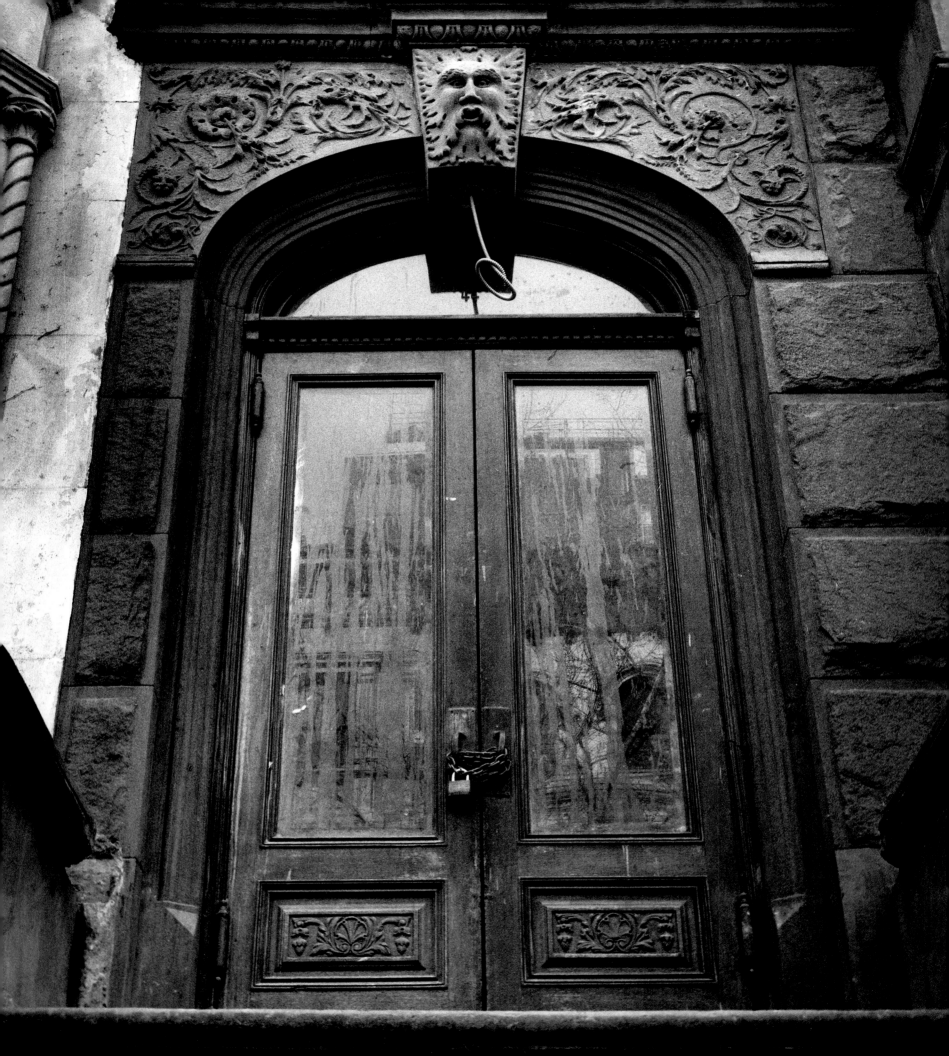

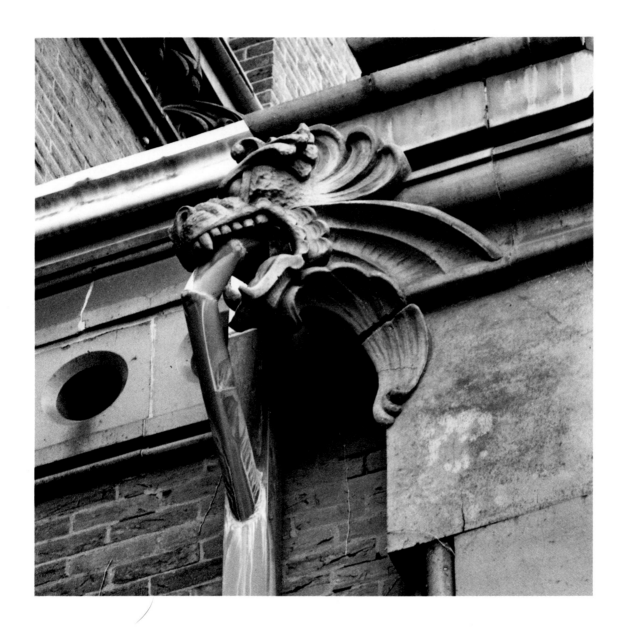

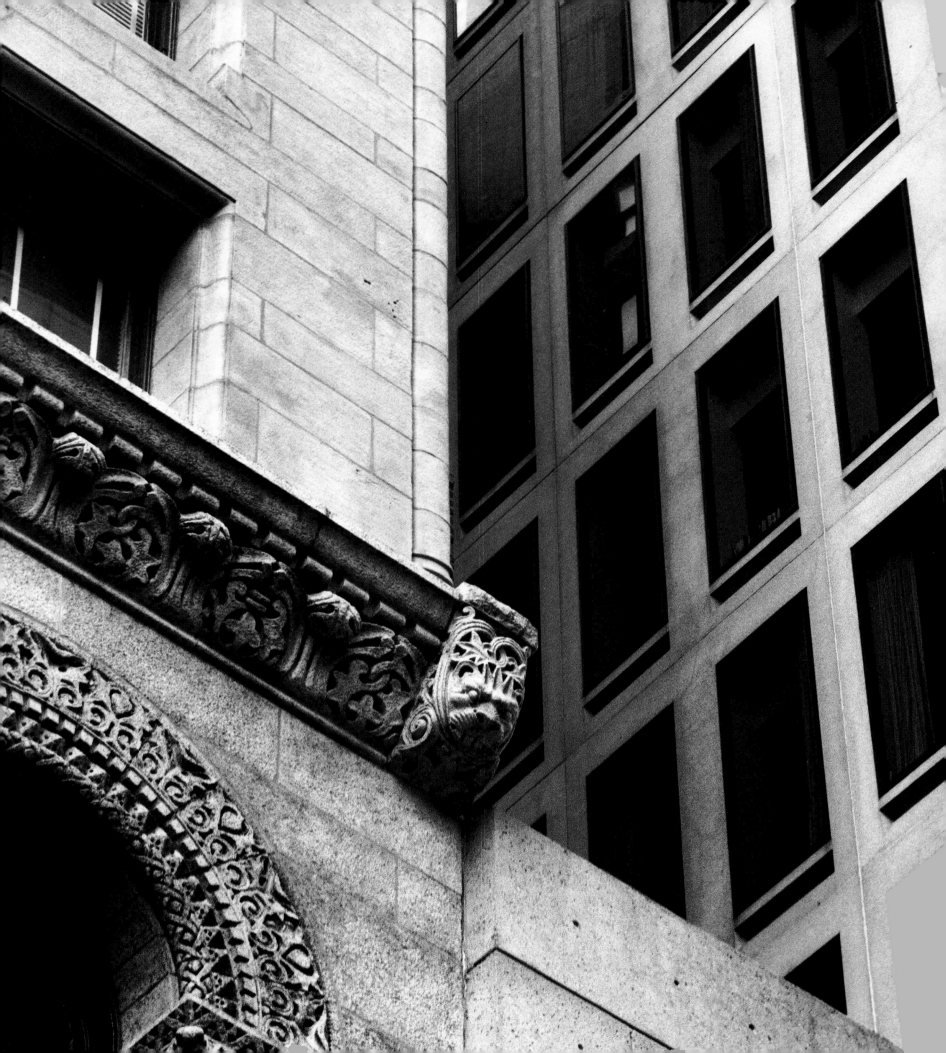

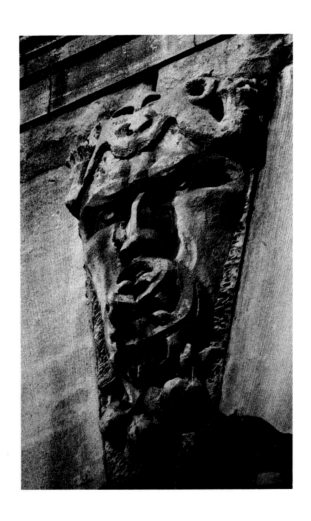

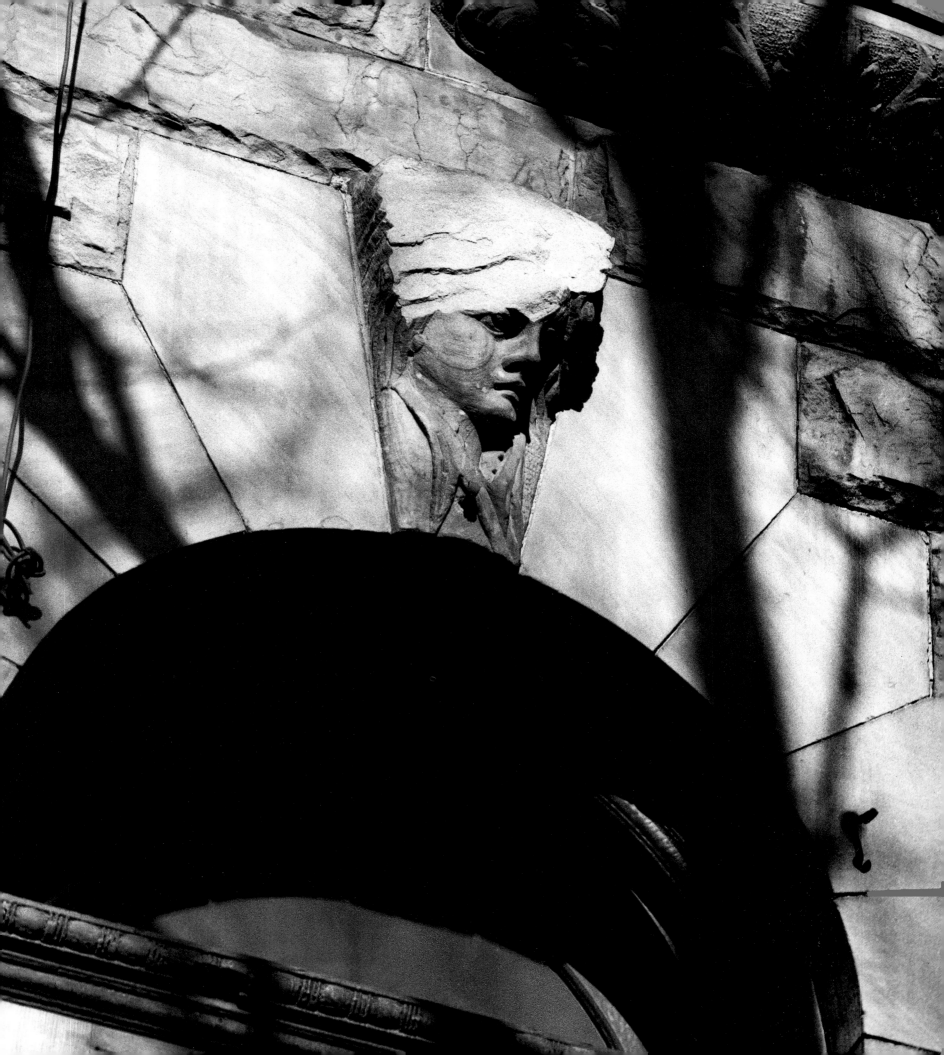

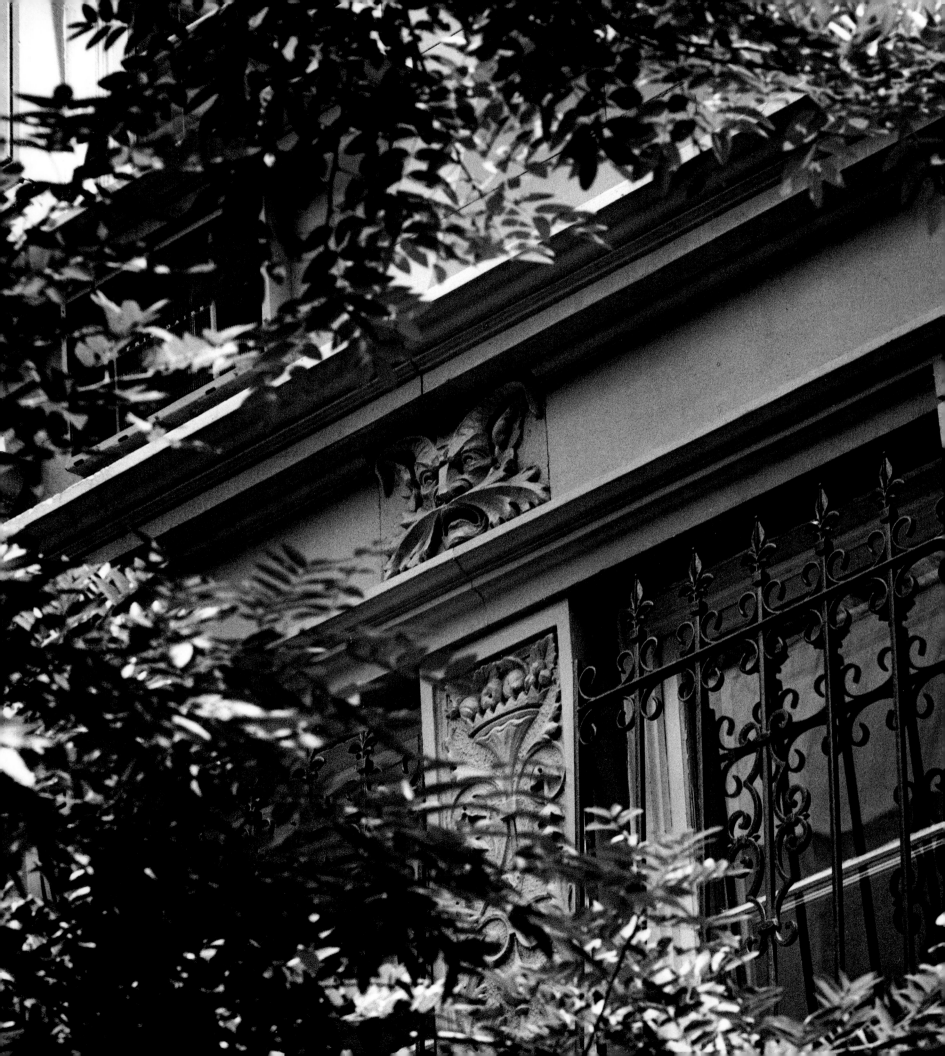

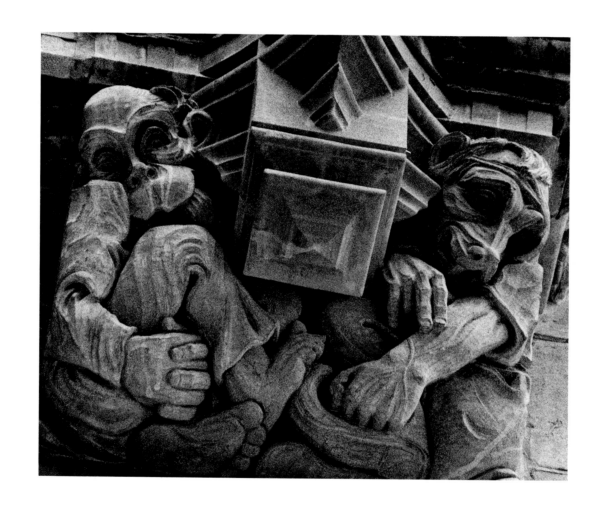

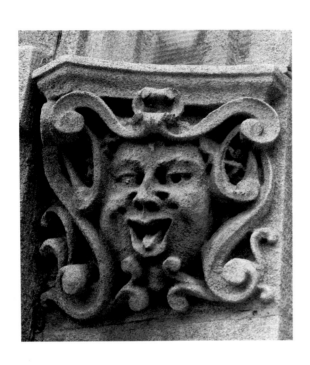

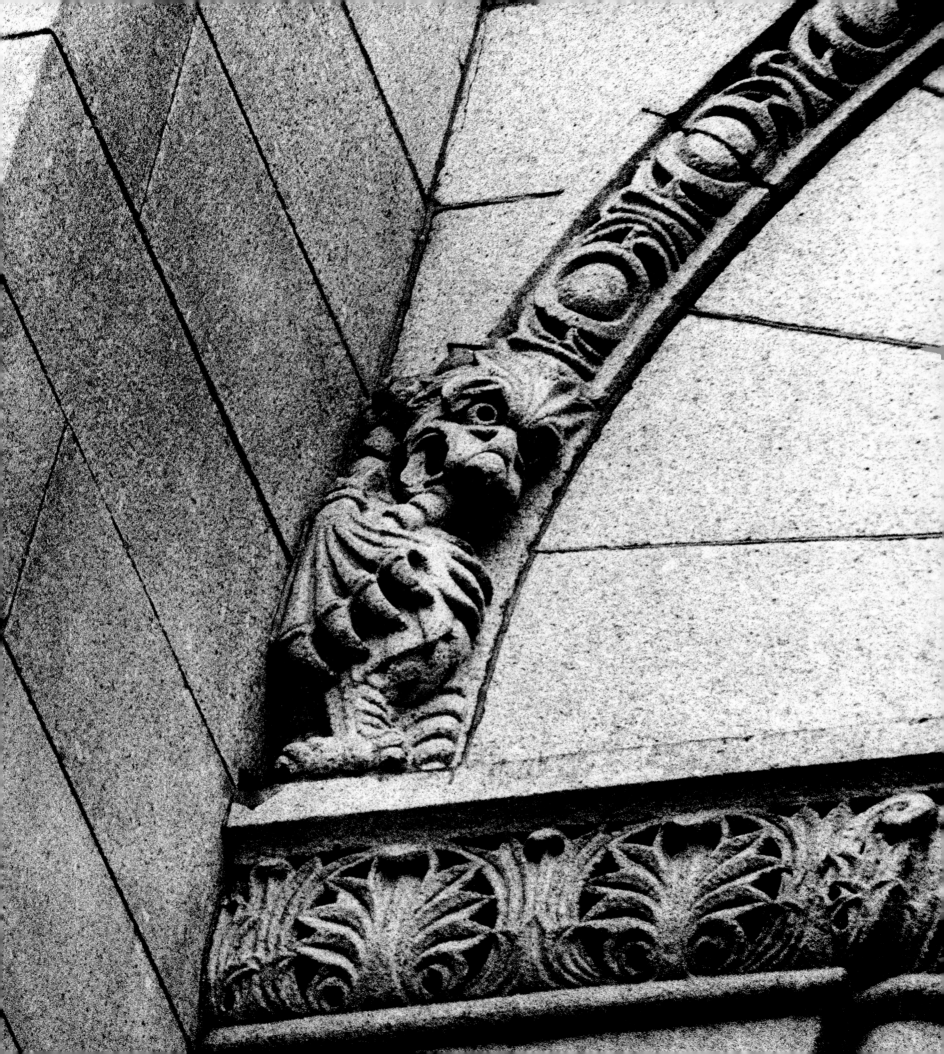

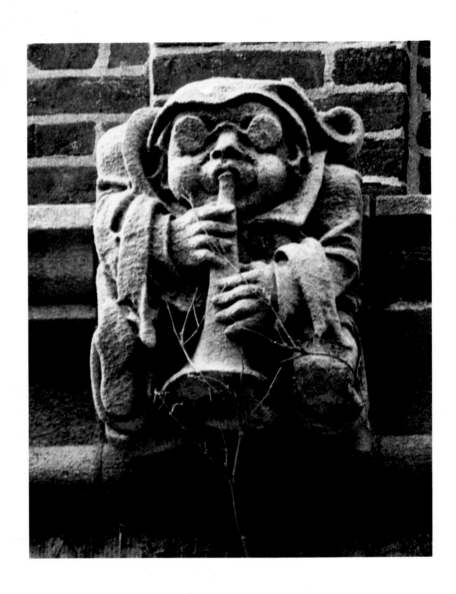

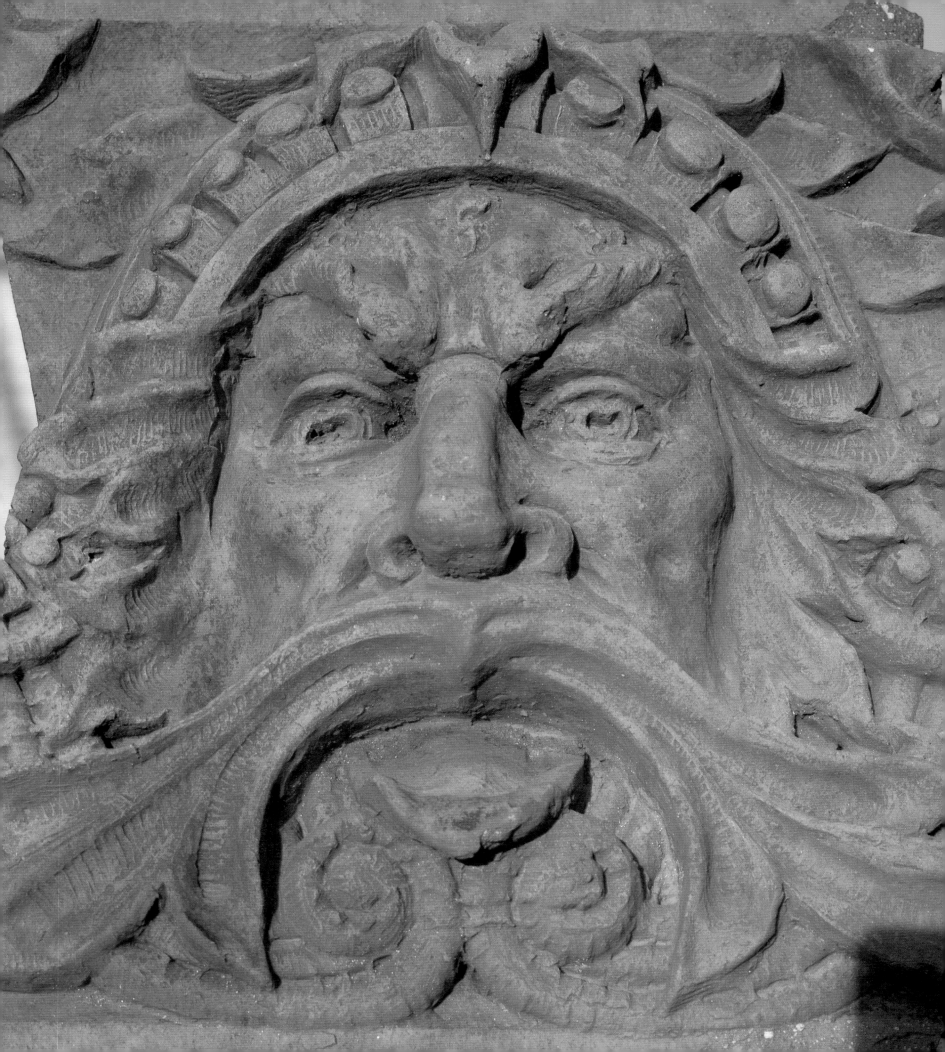

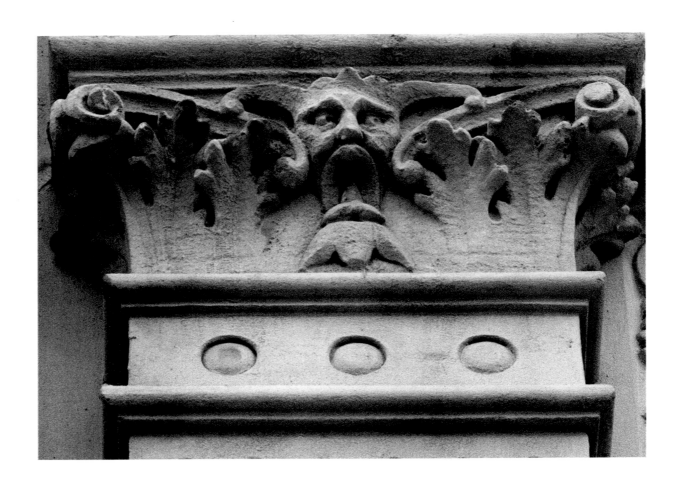

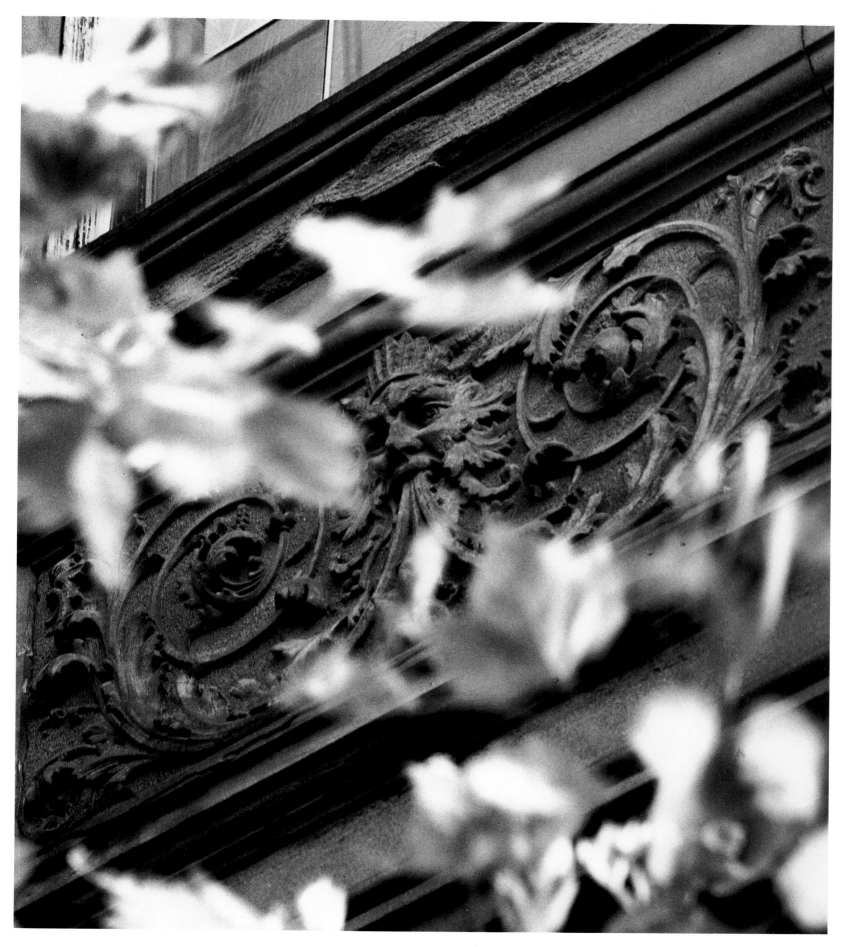

51

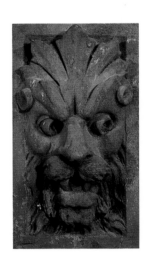

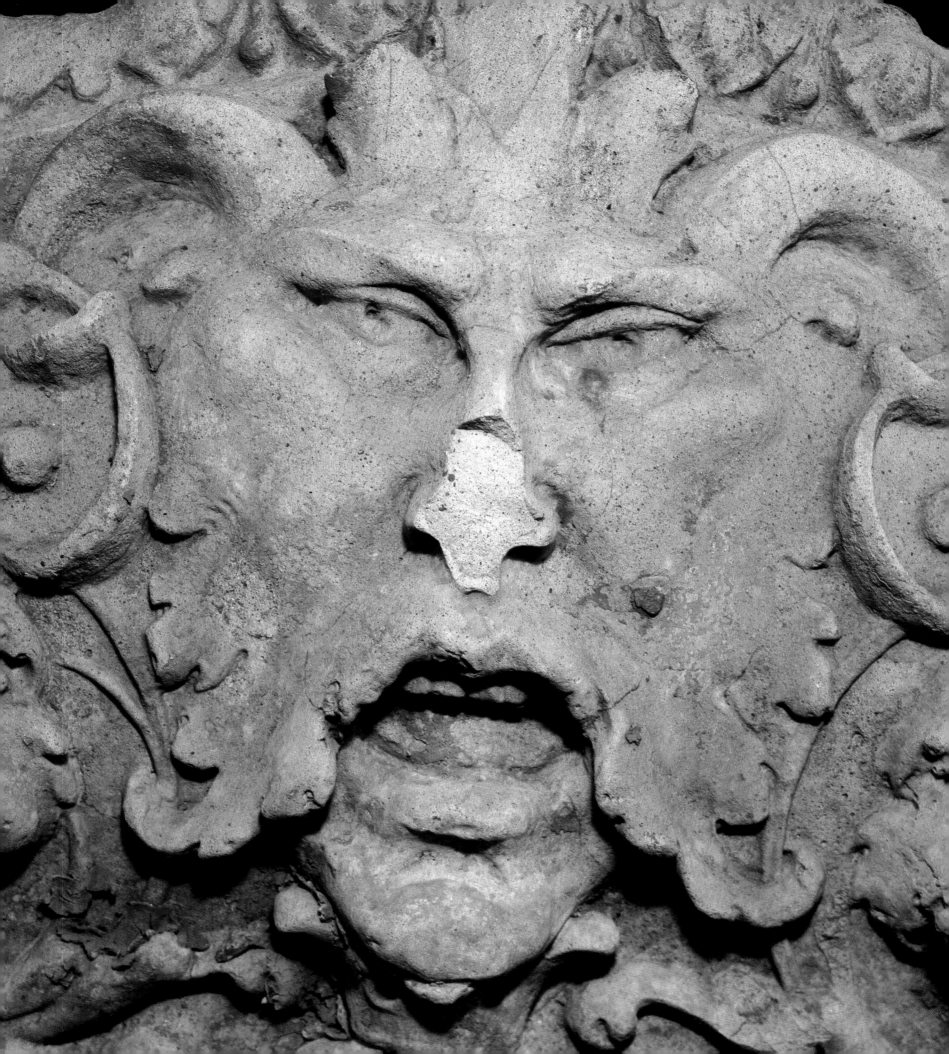

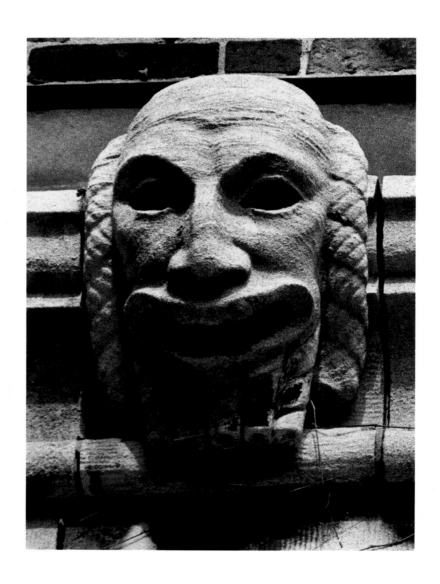

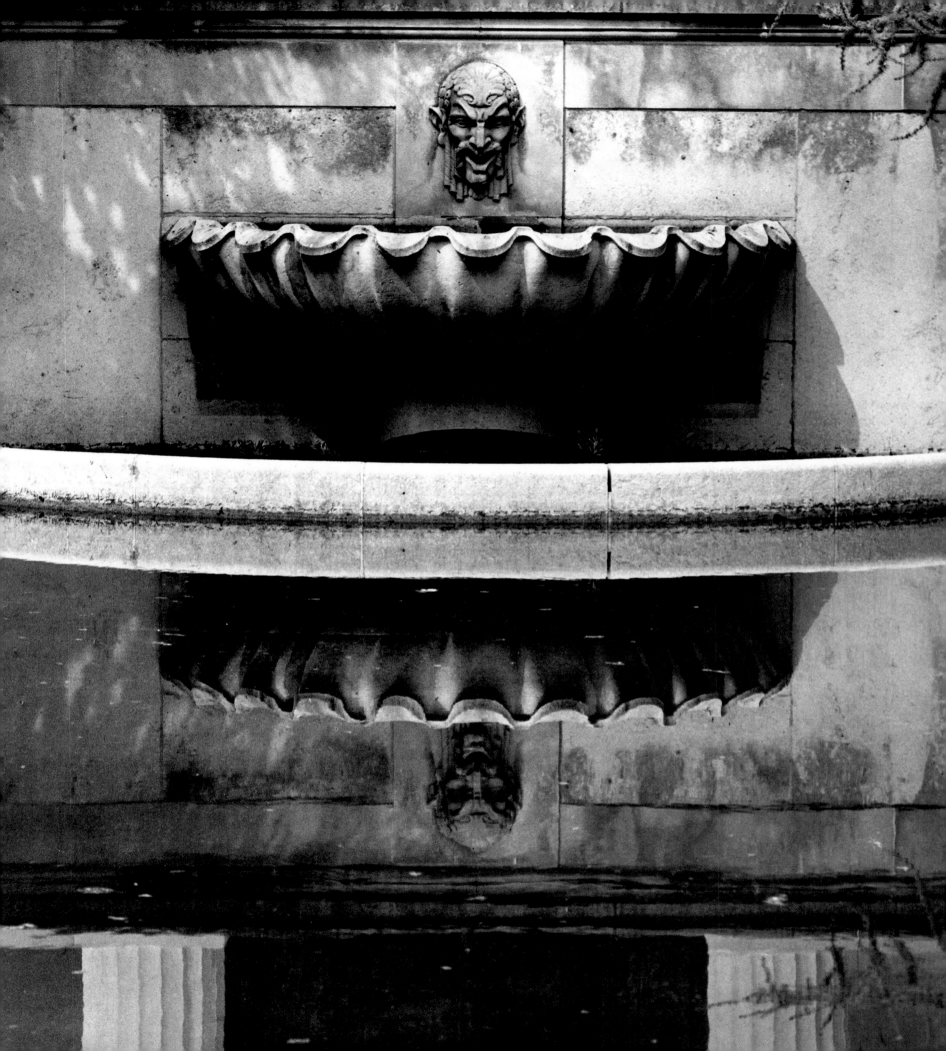

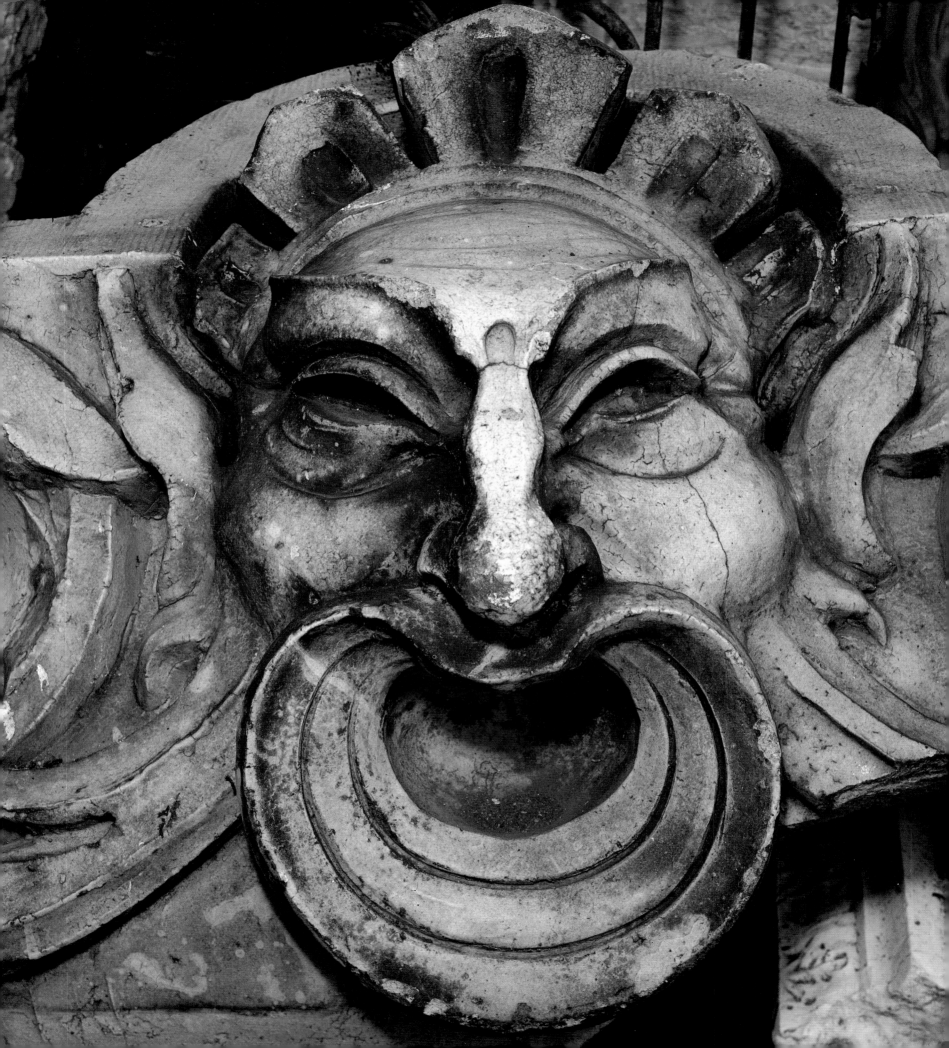

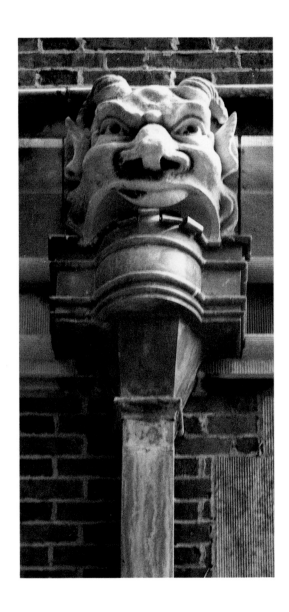

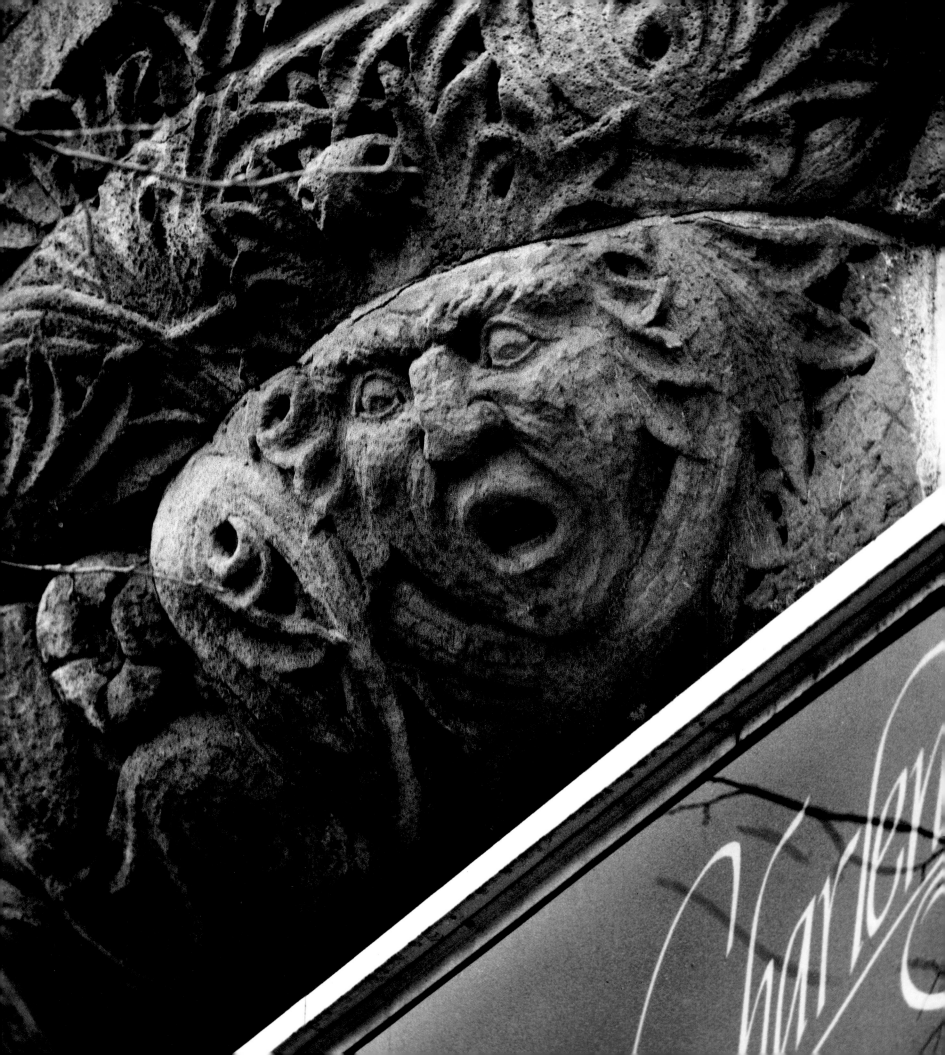

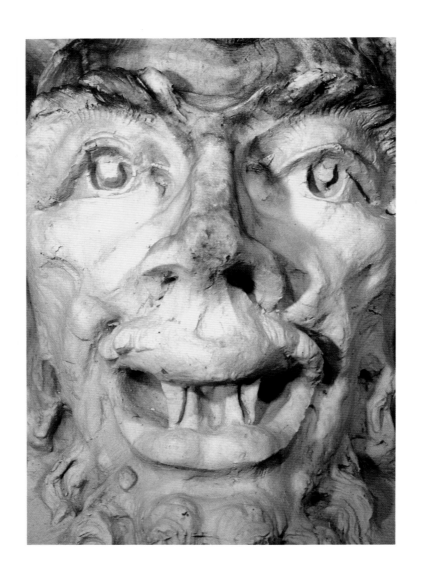

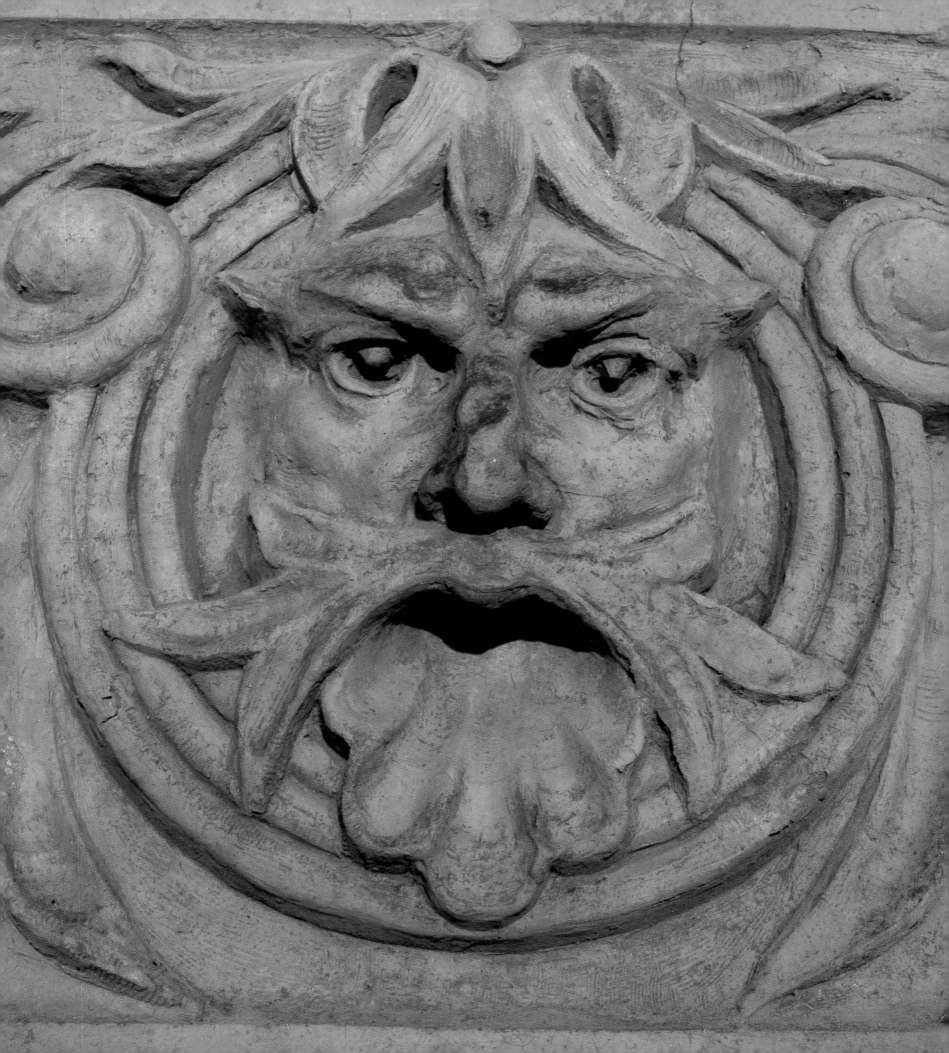

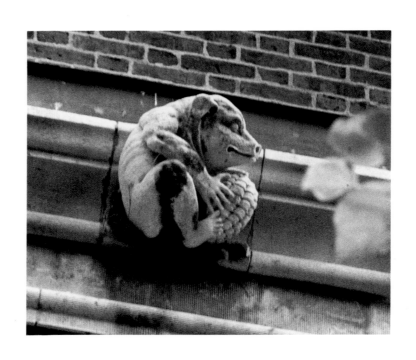

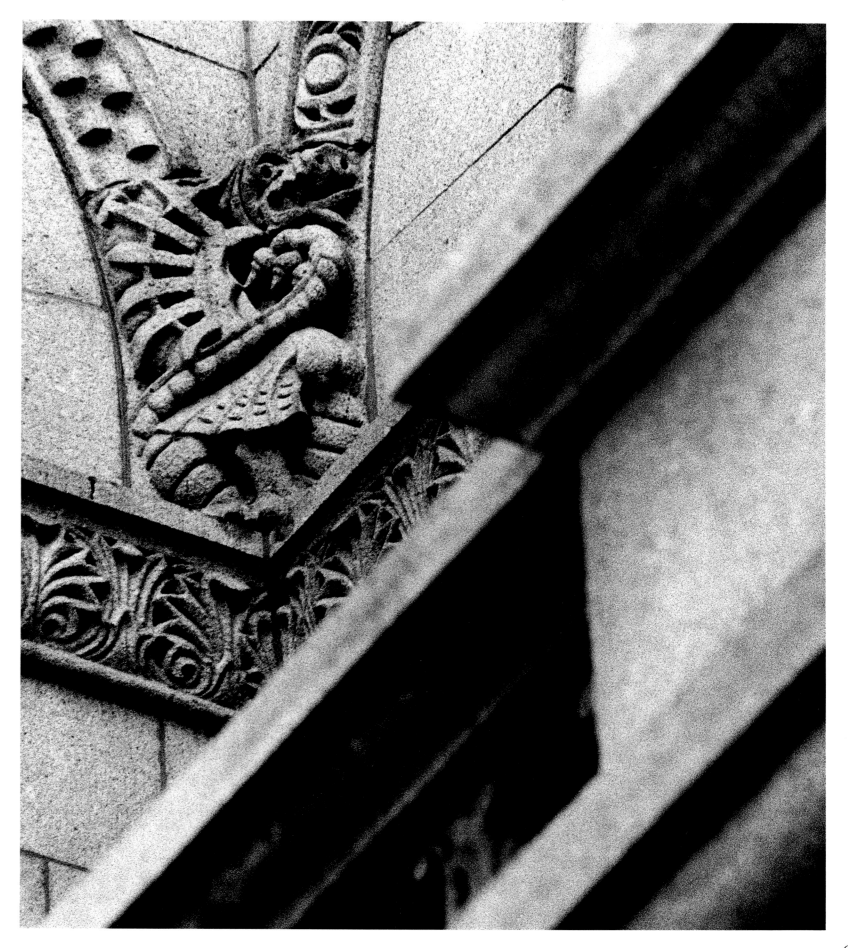

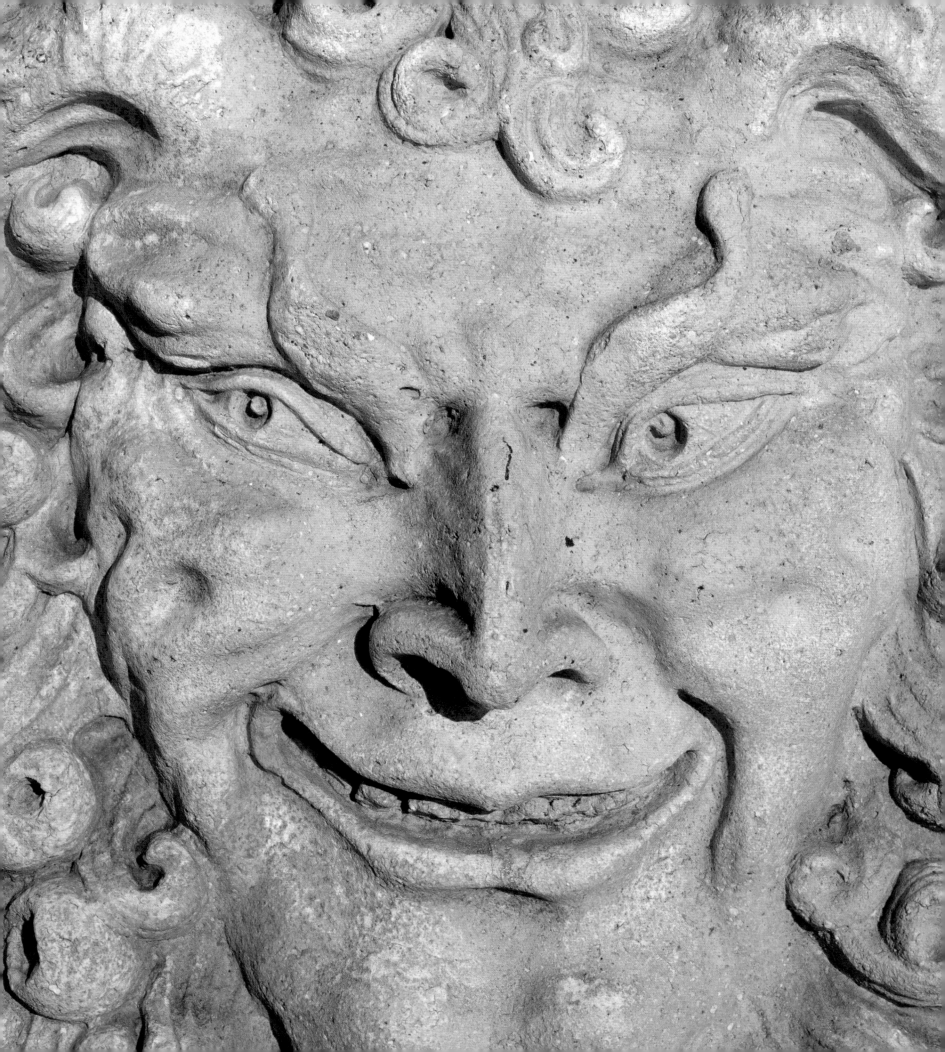

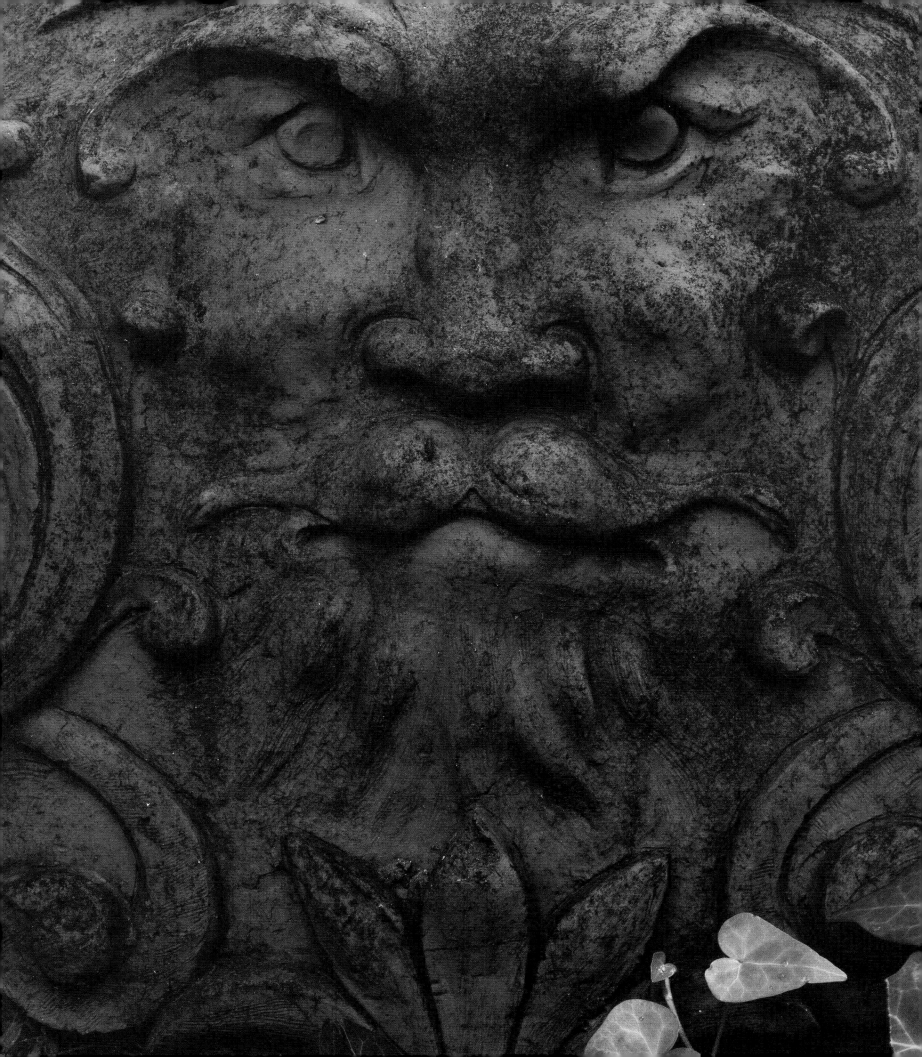

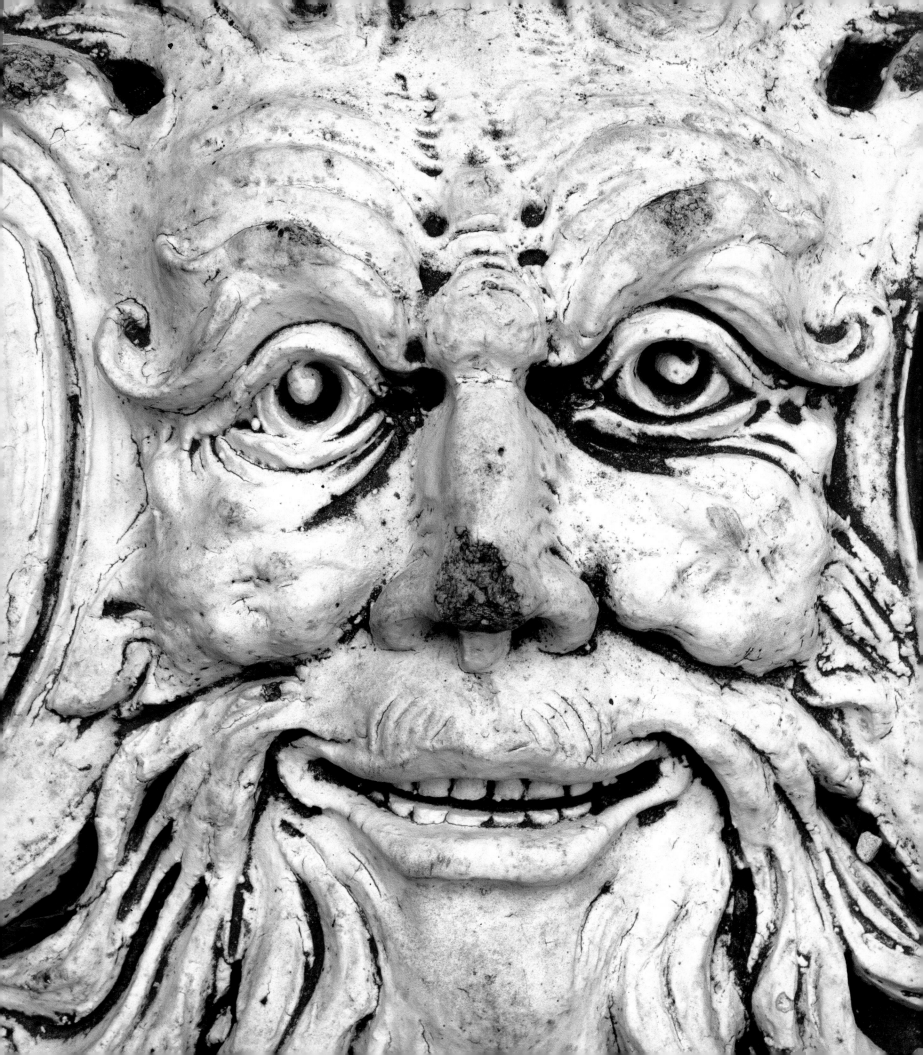

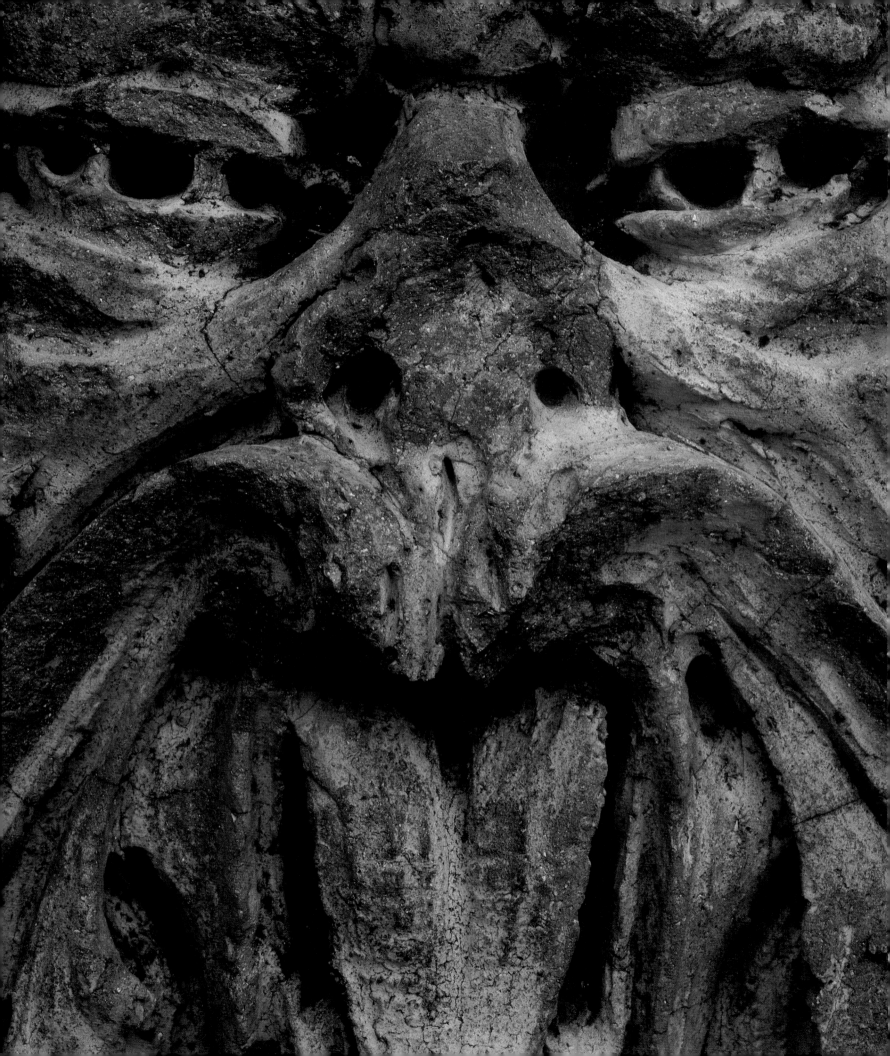

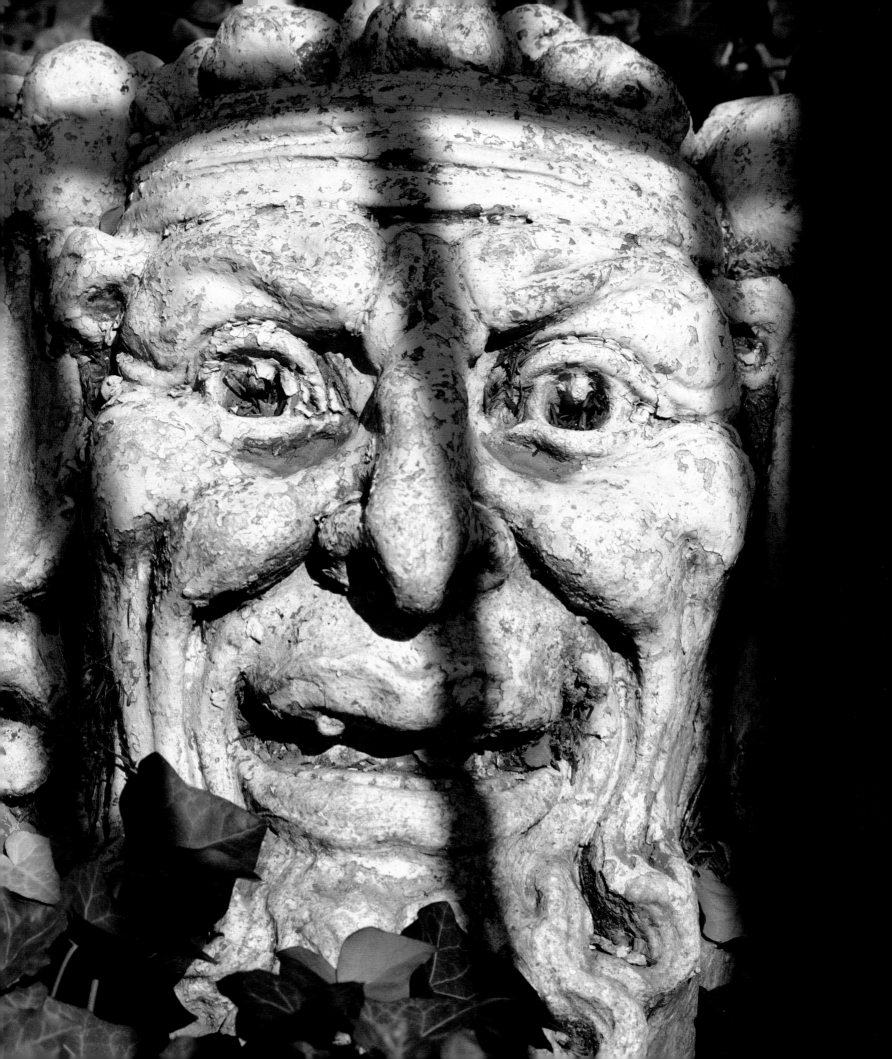

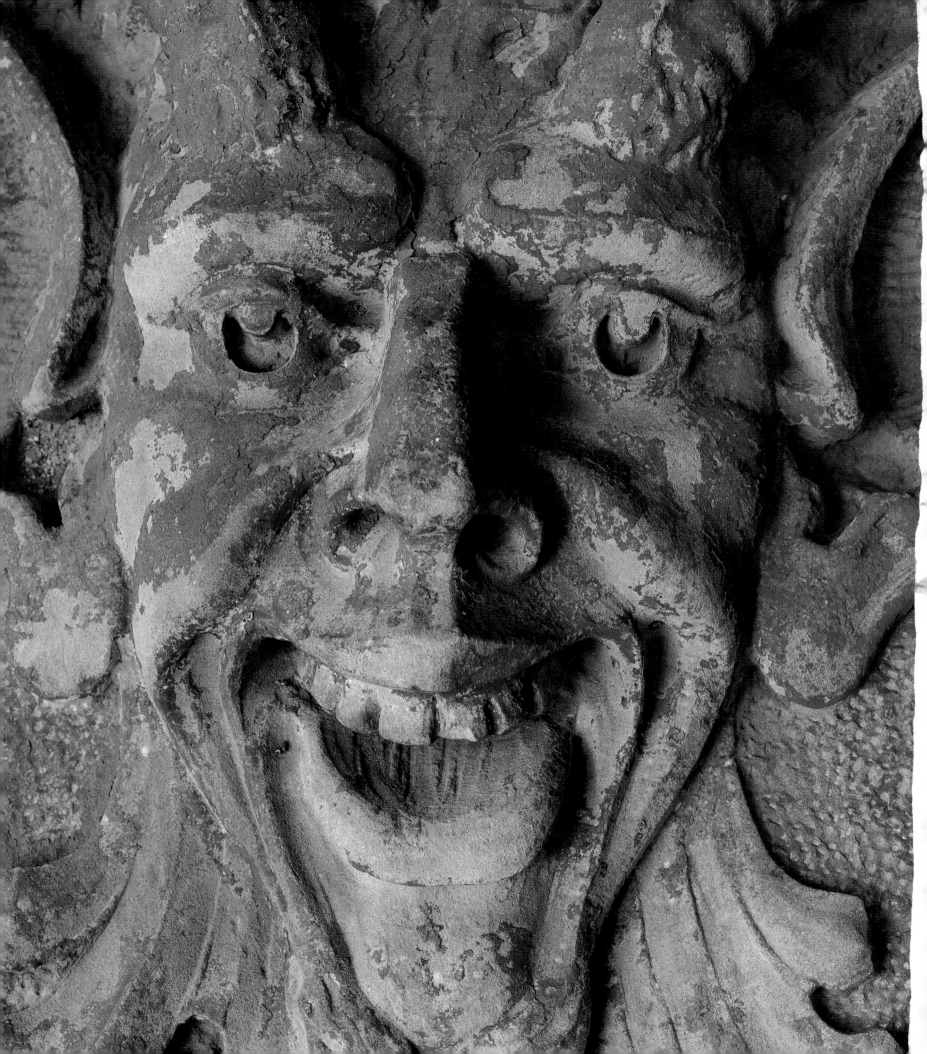

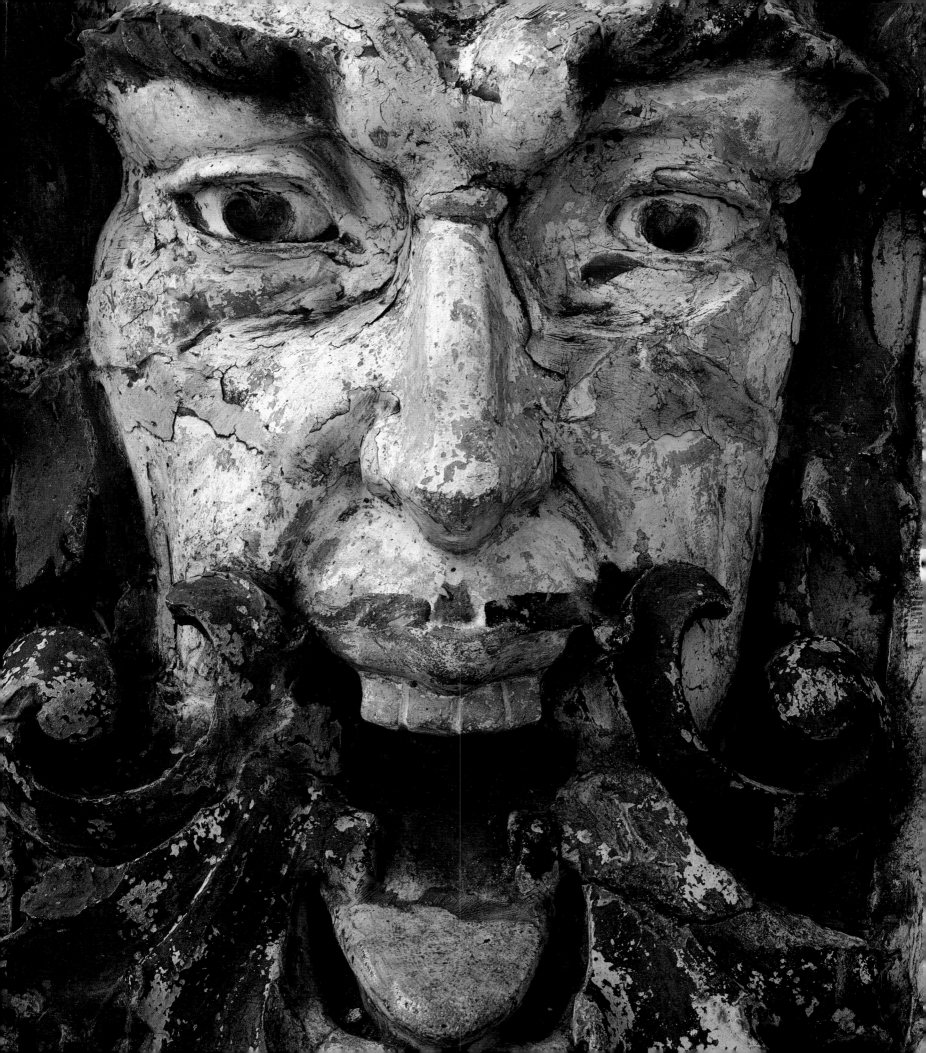

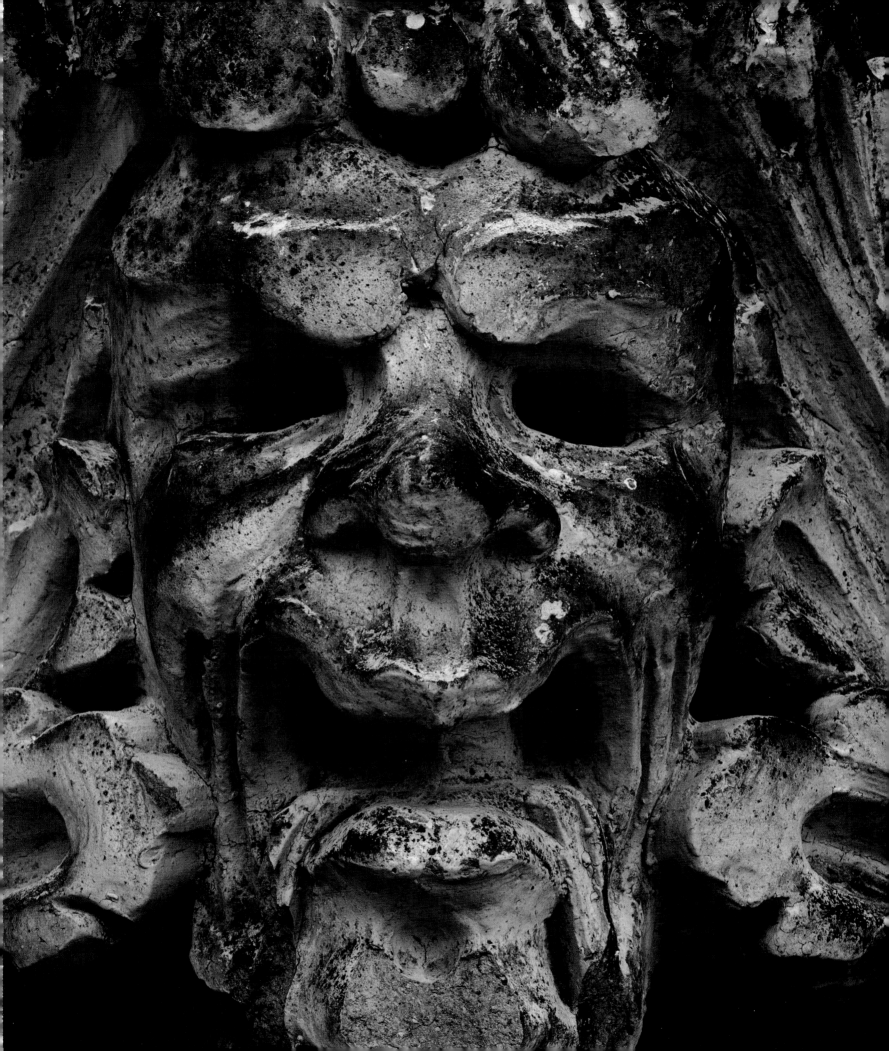

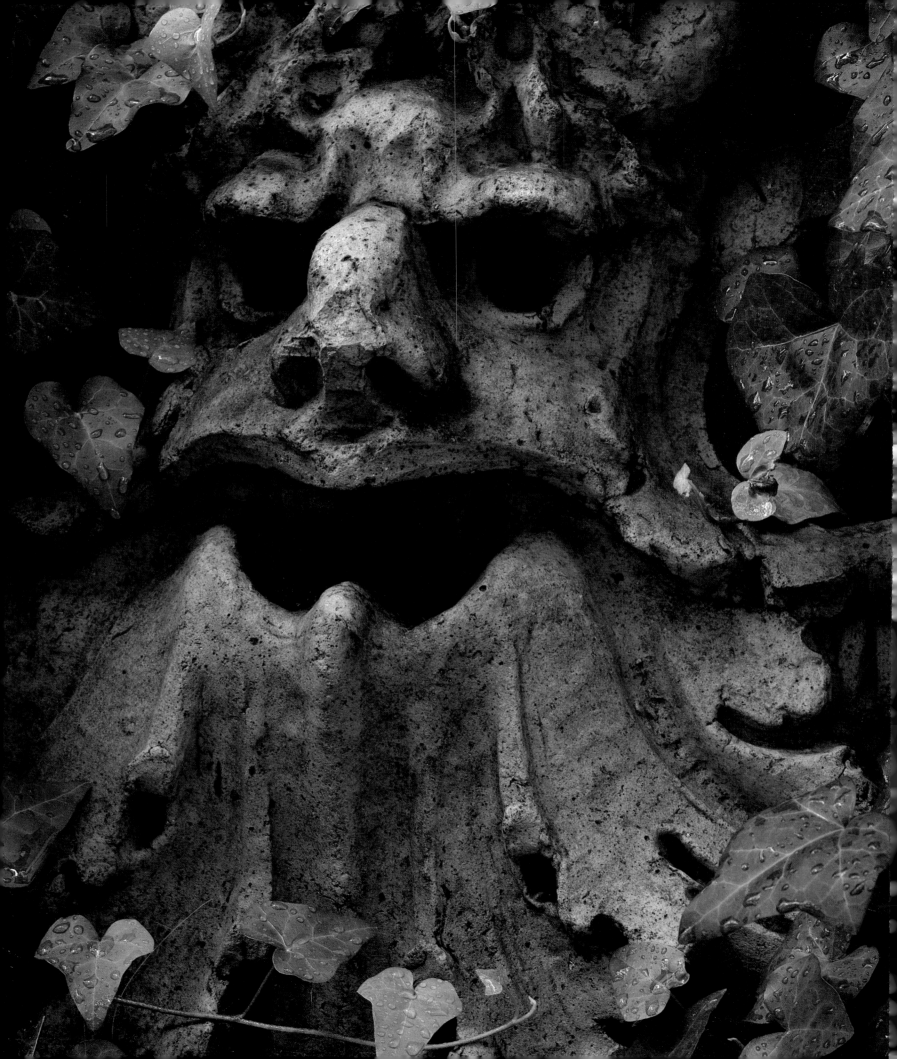

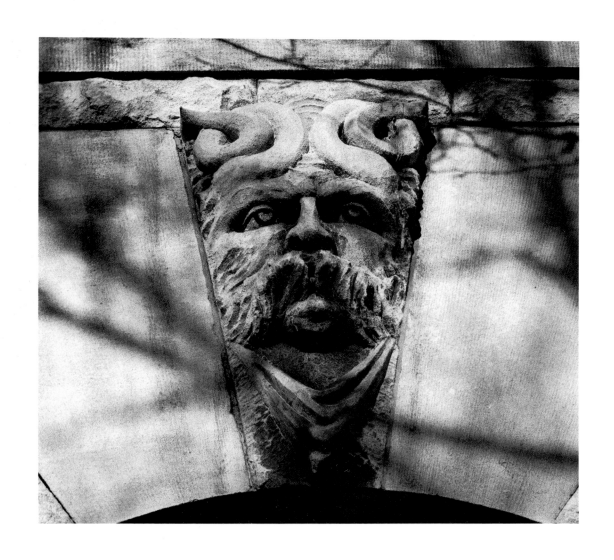

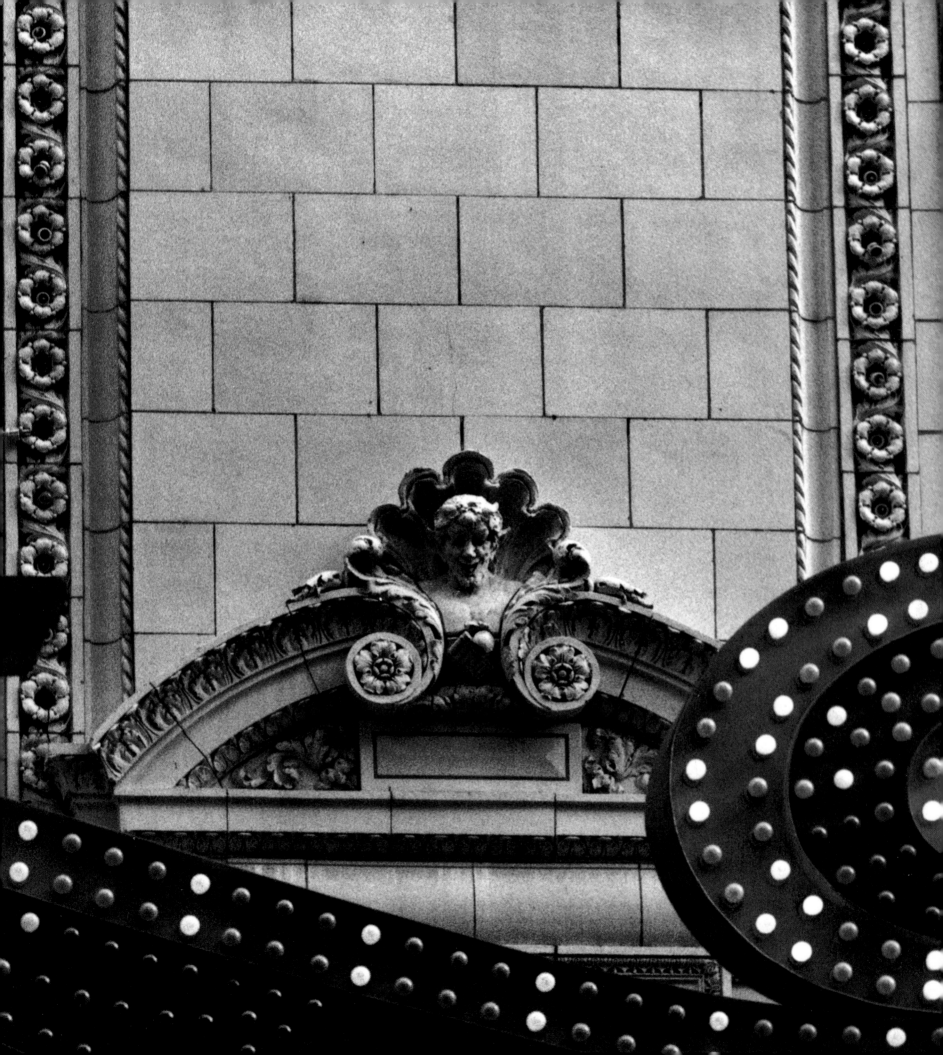

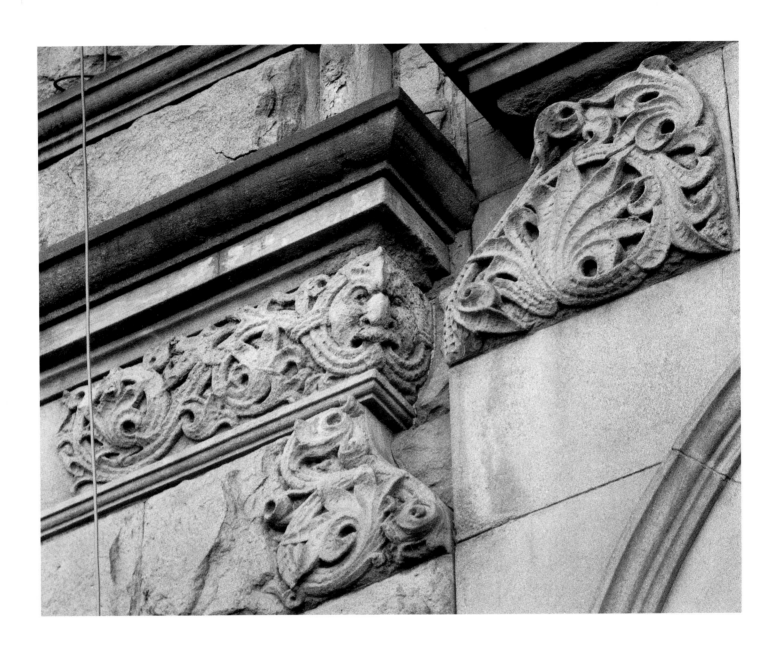

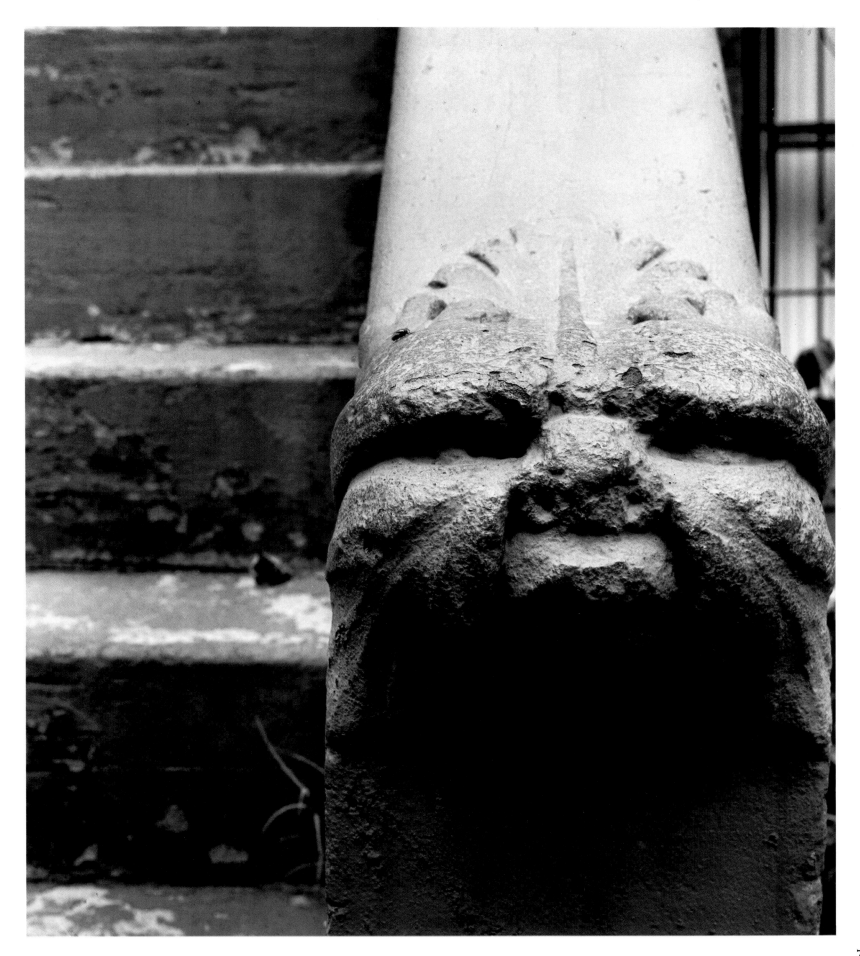

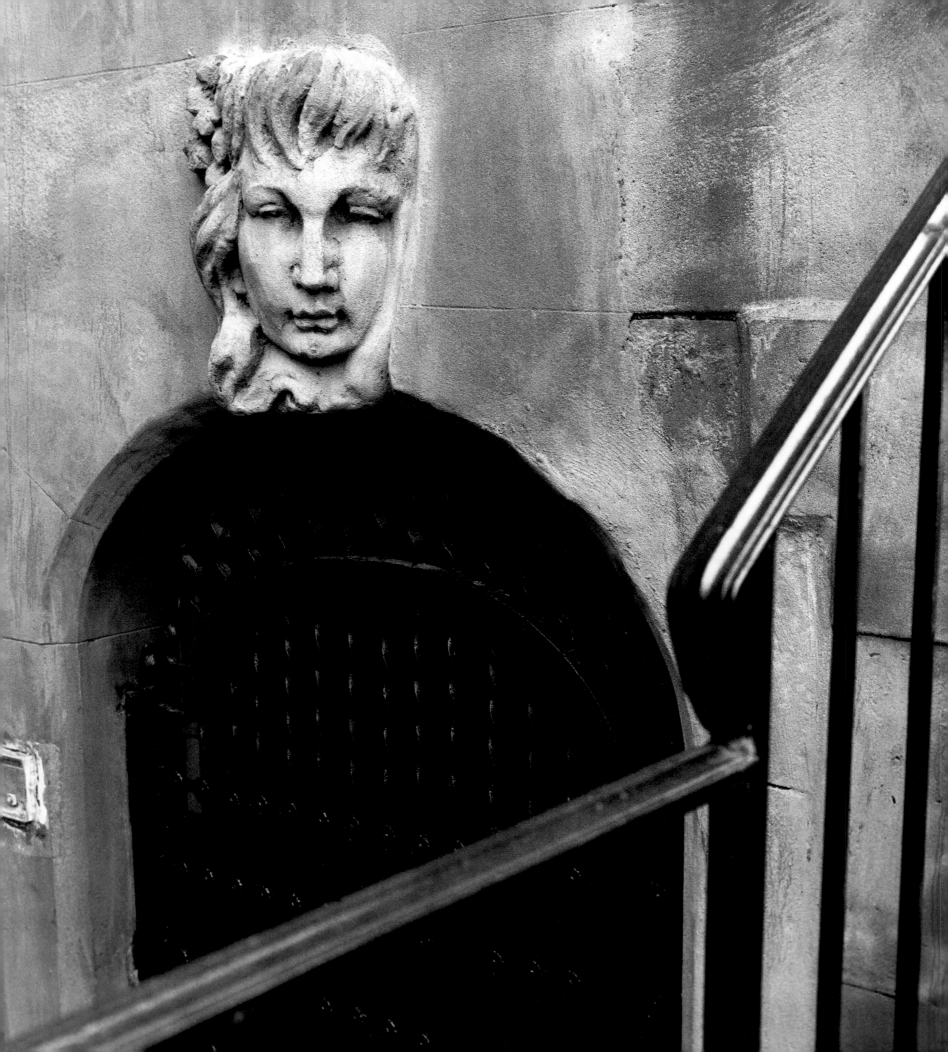

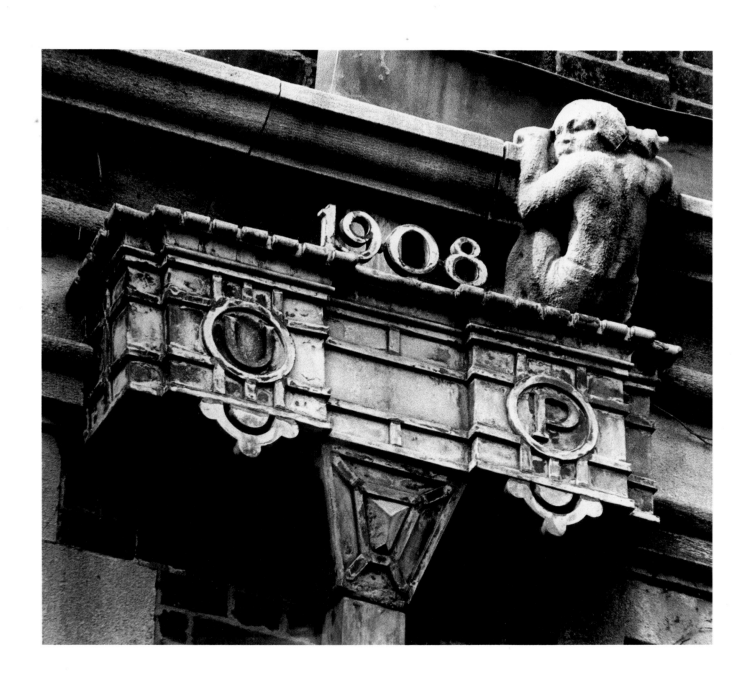

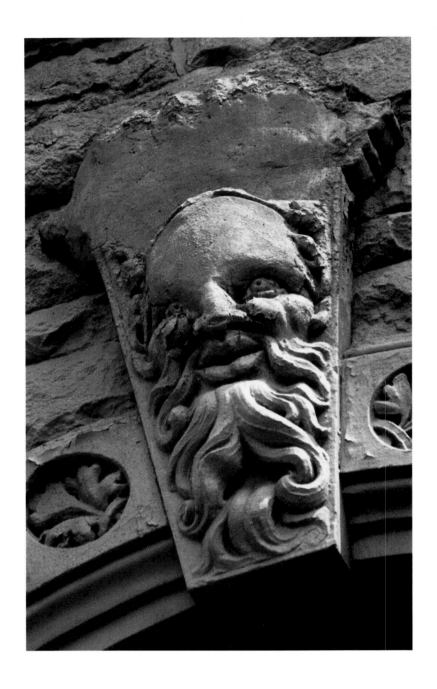

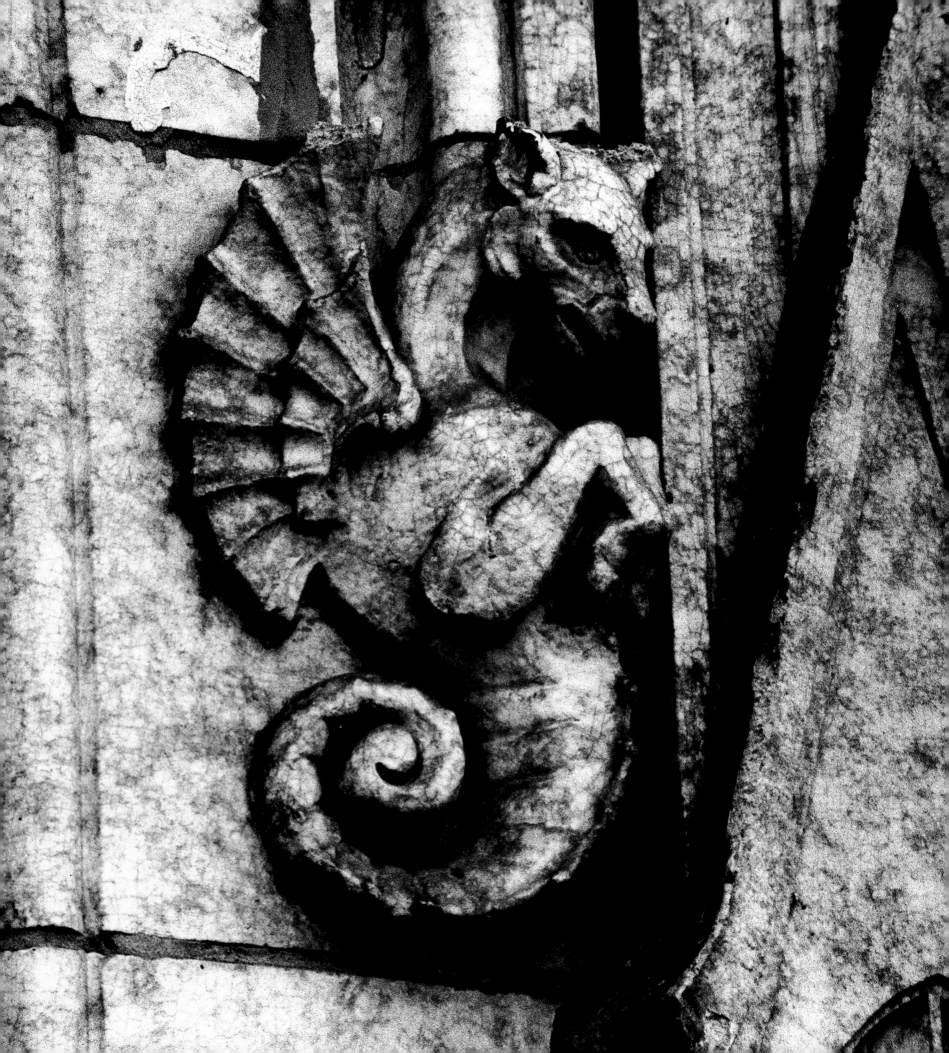

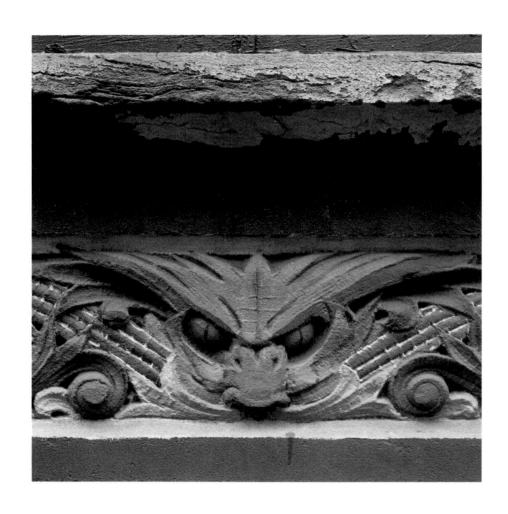

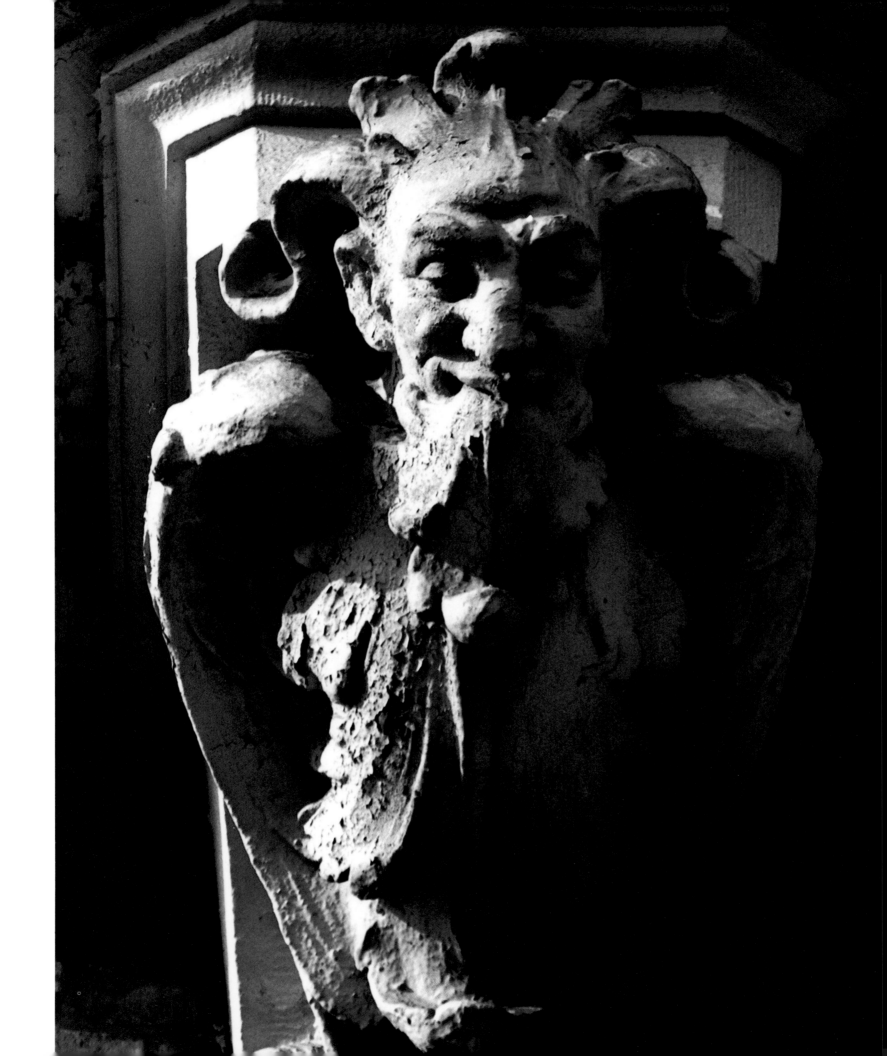

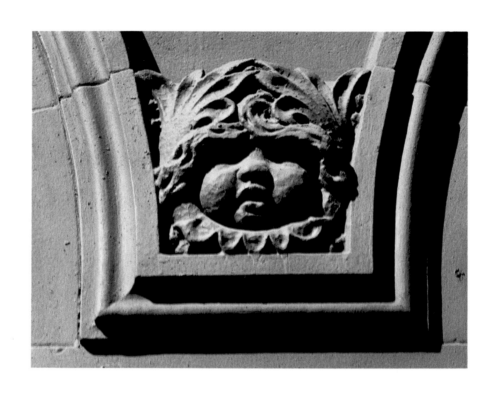

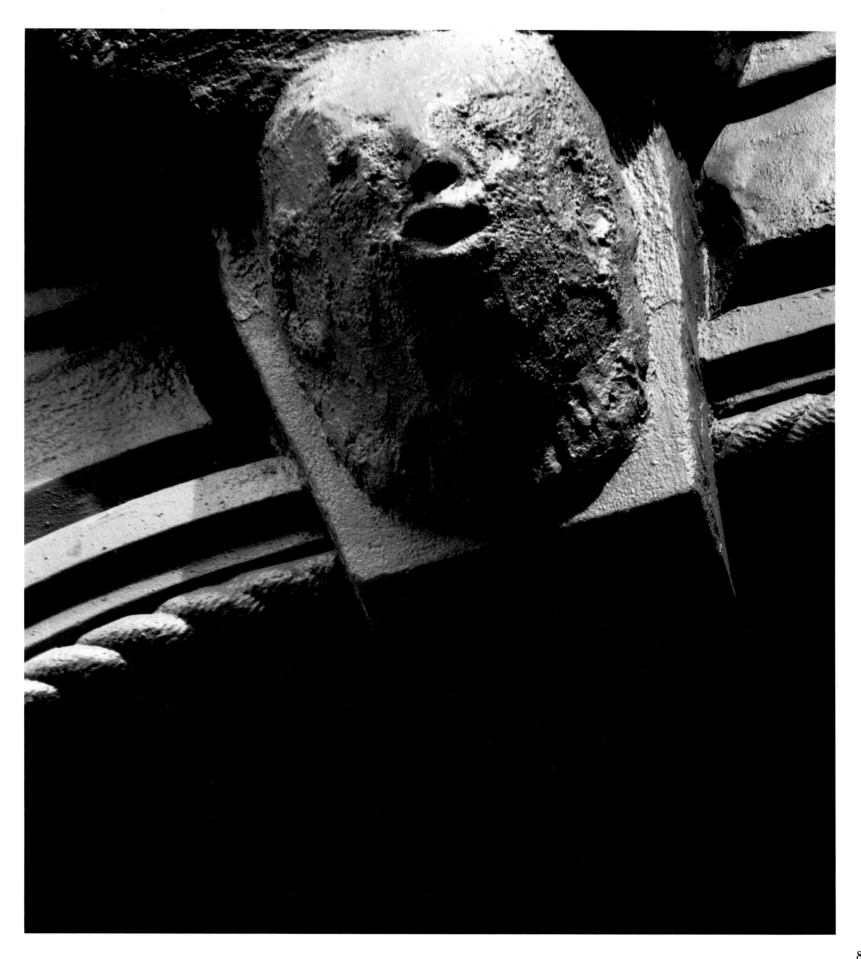

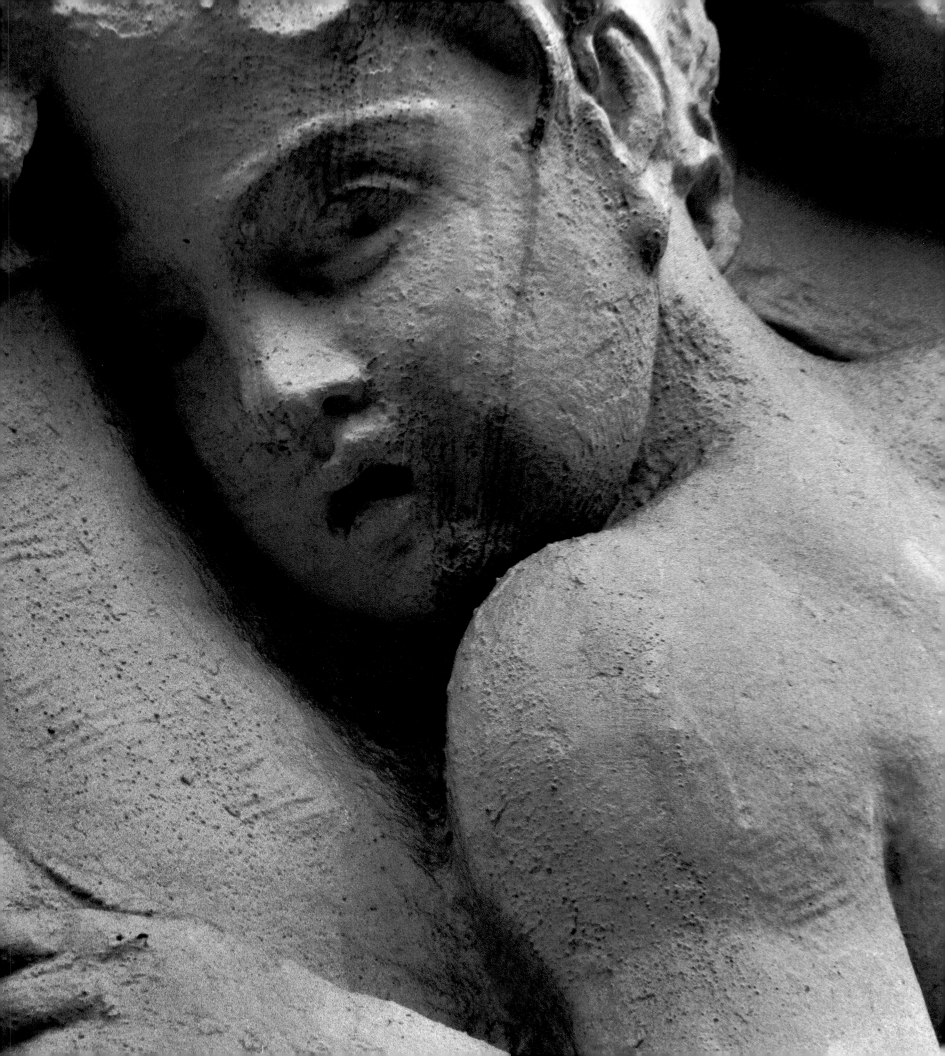

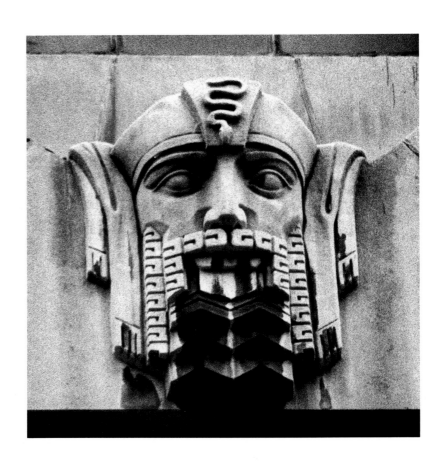

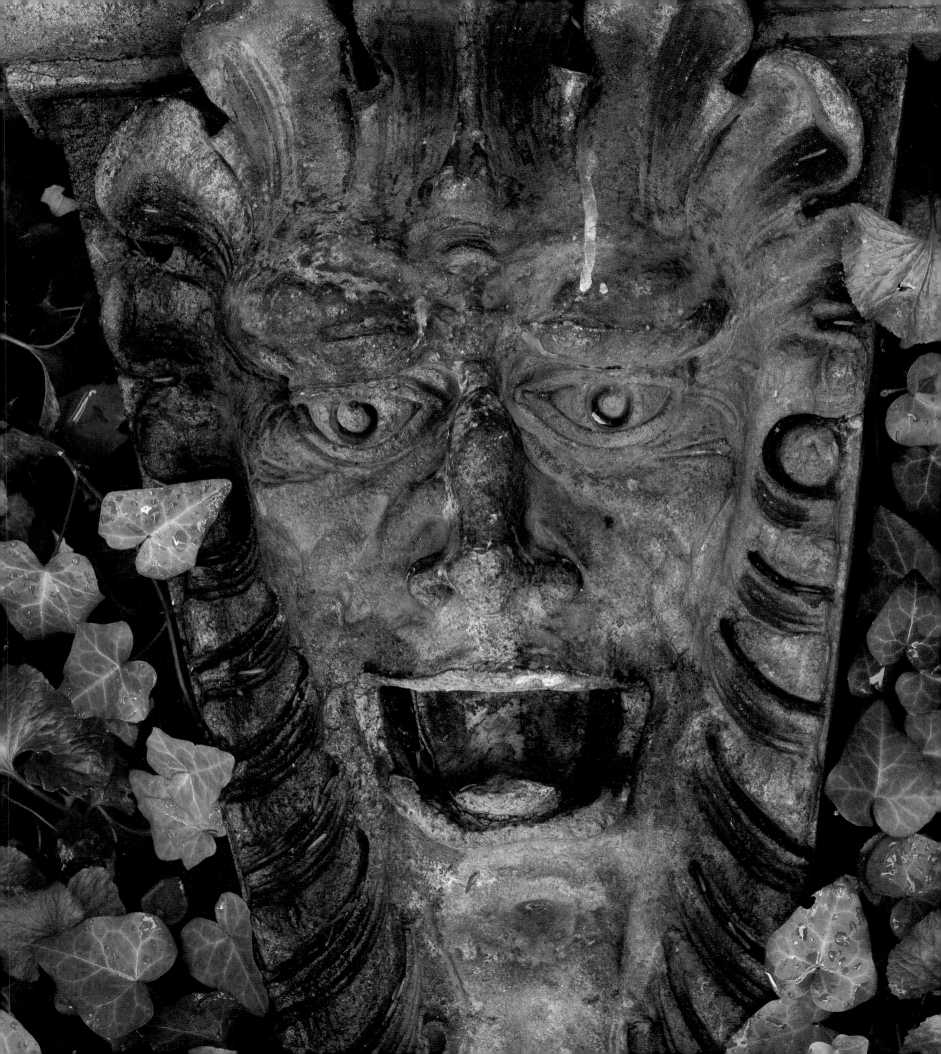

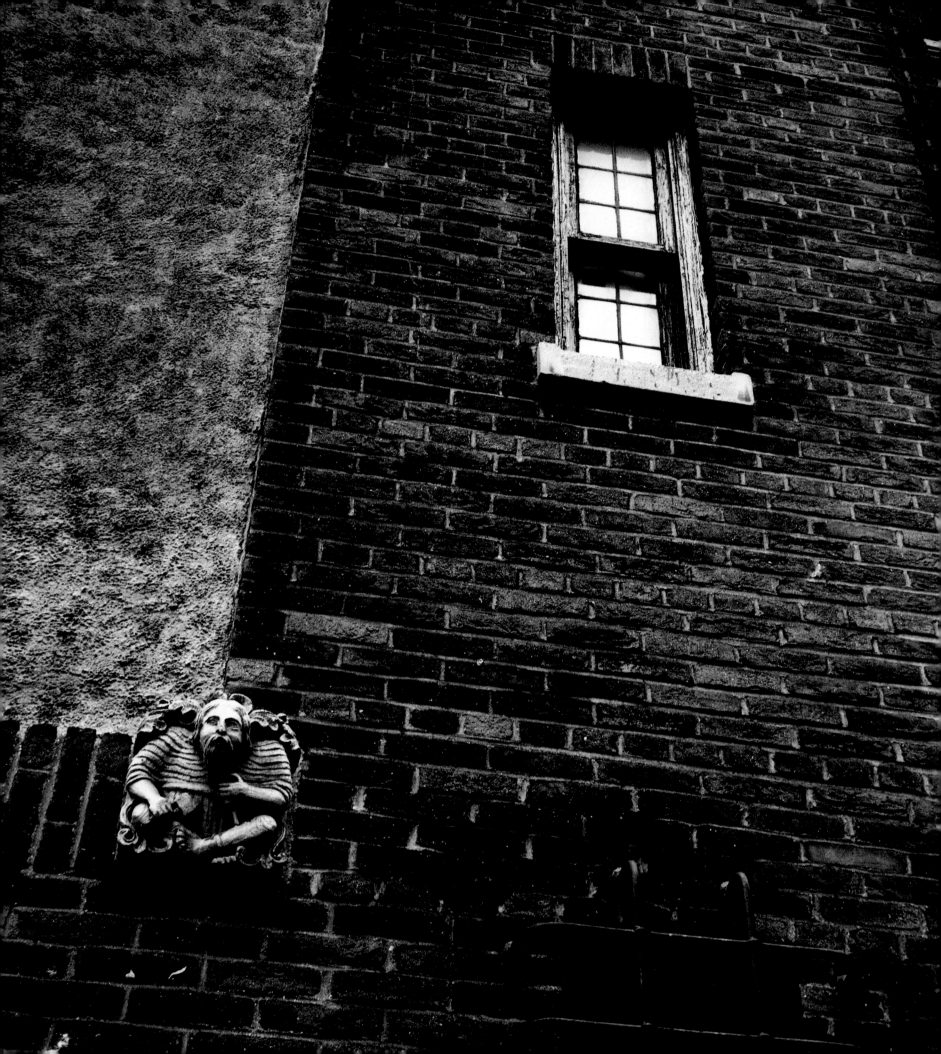

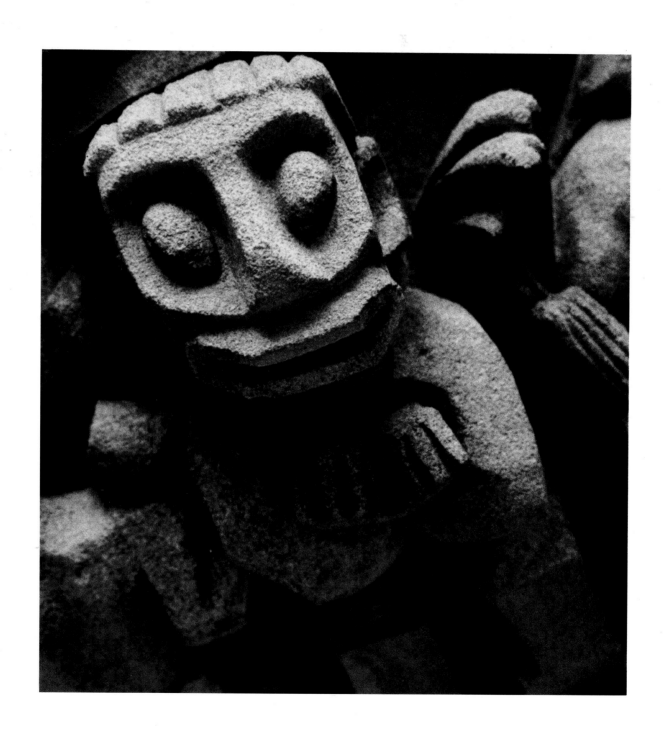

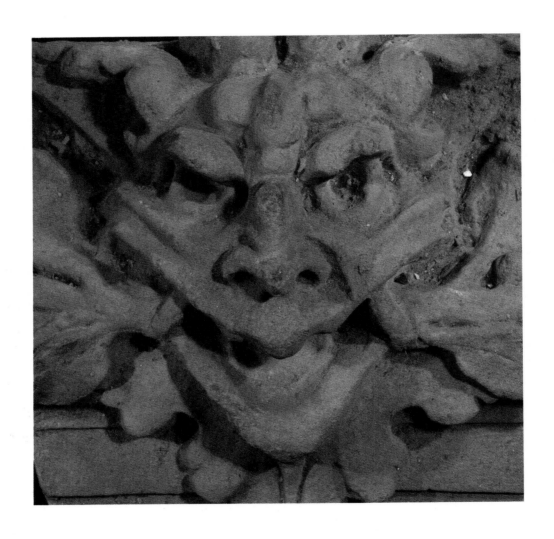

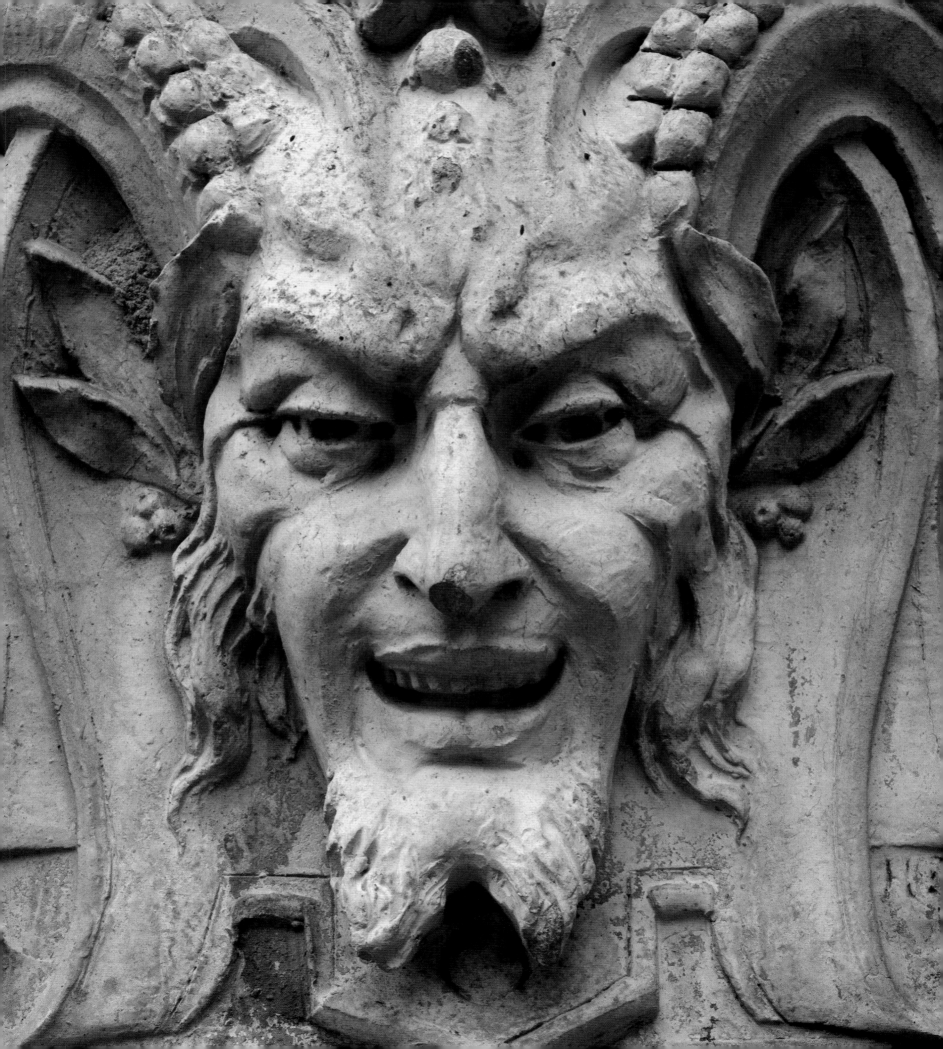

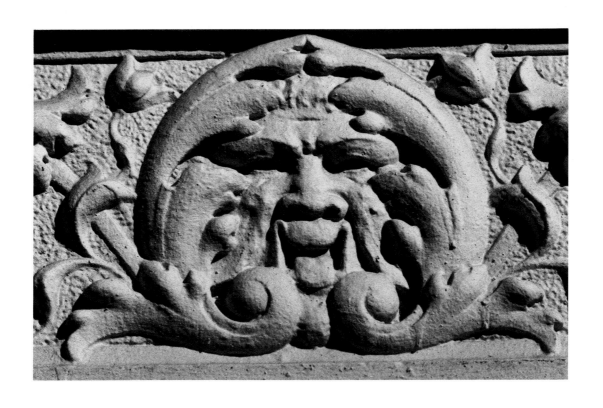

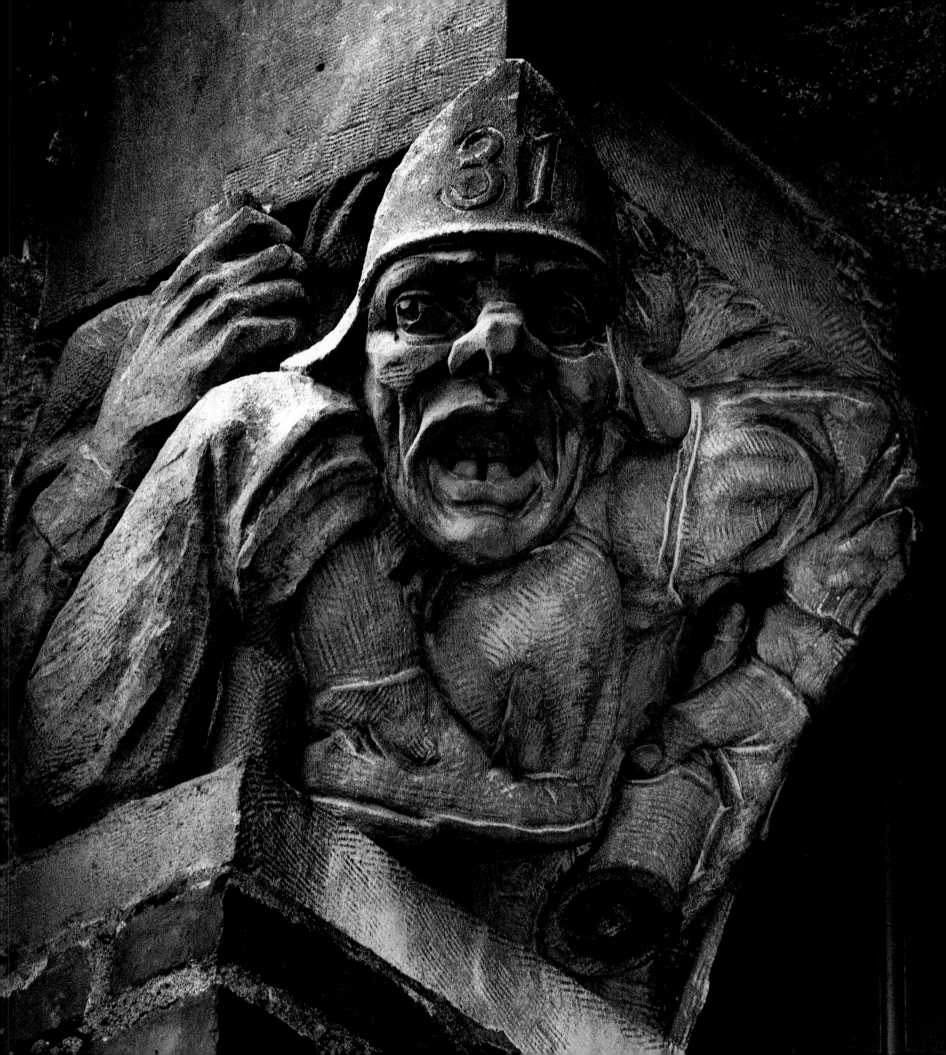

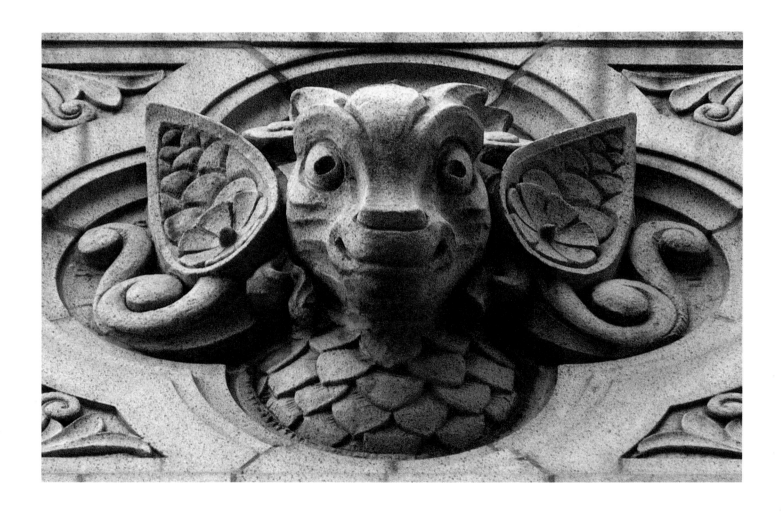

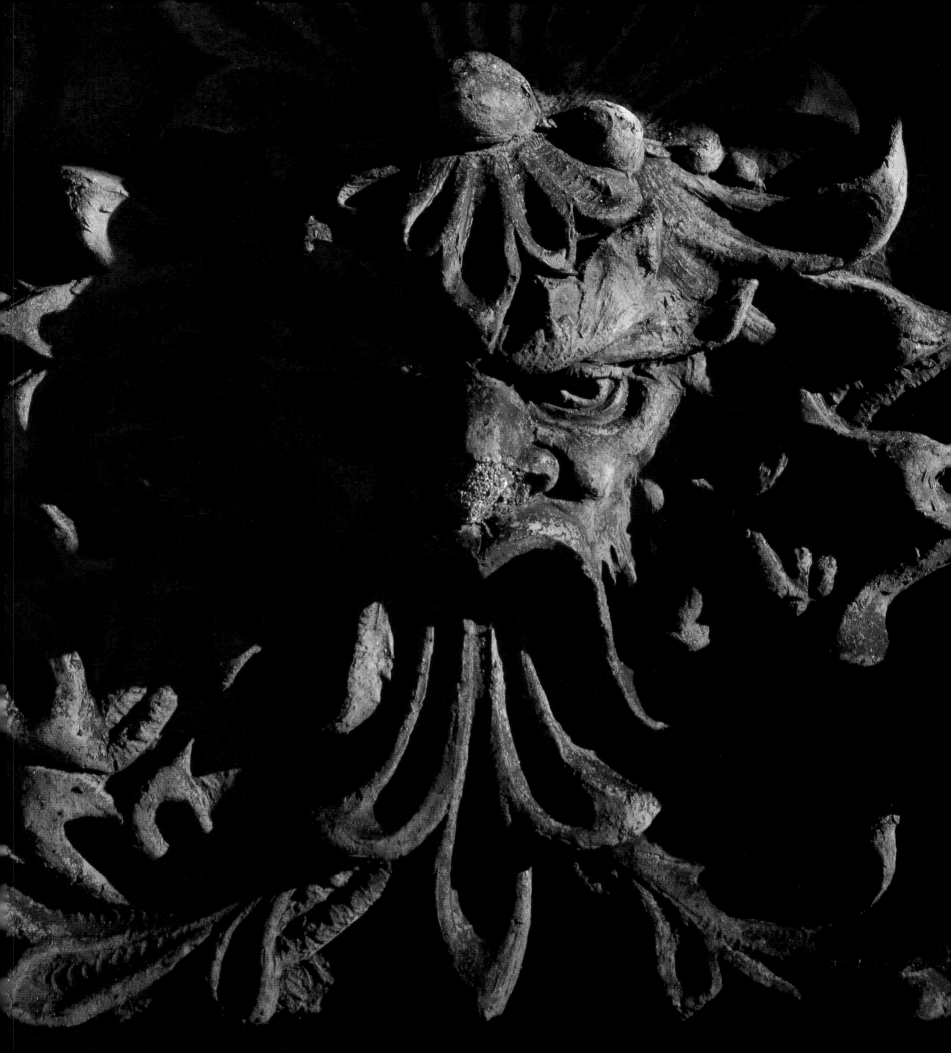

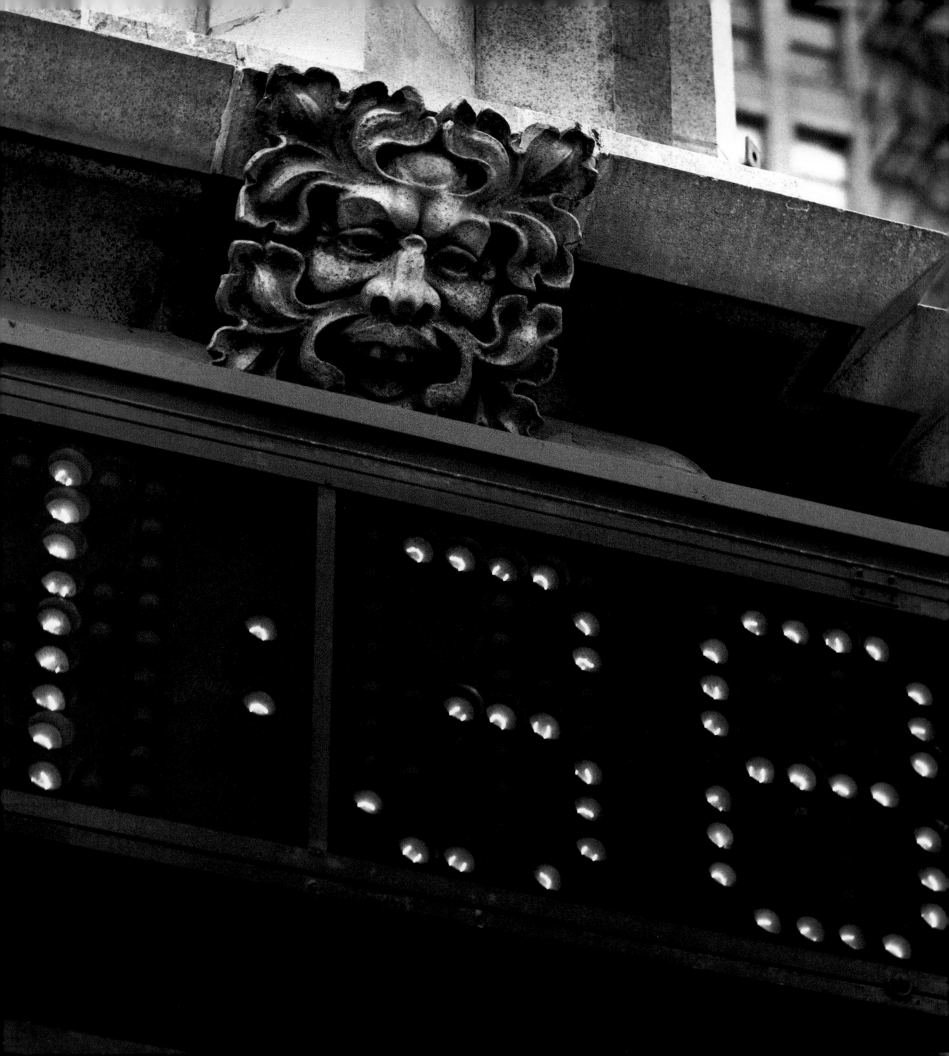

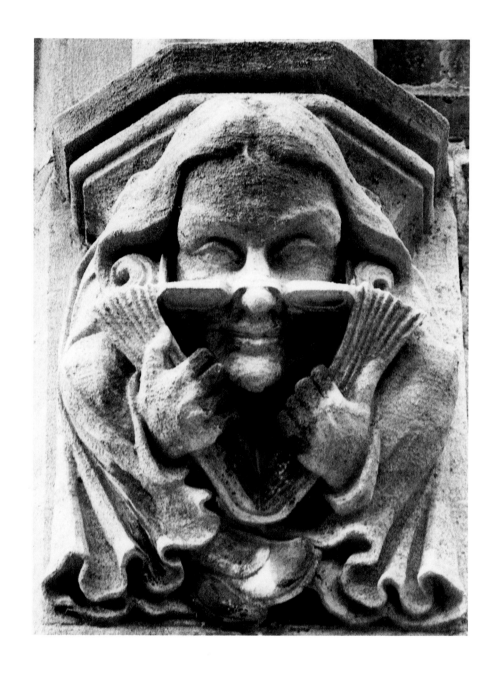

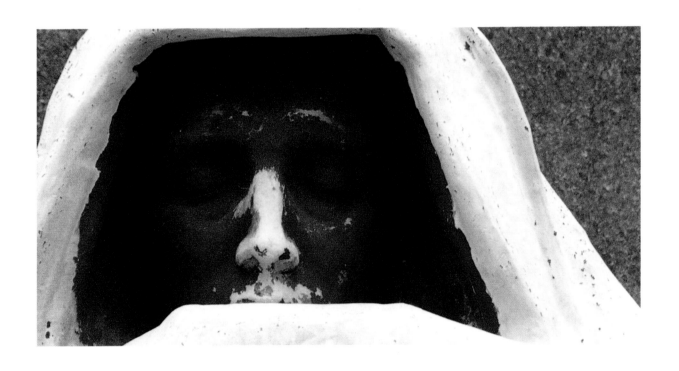

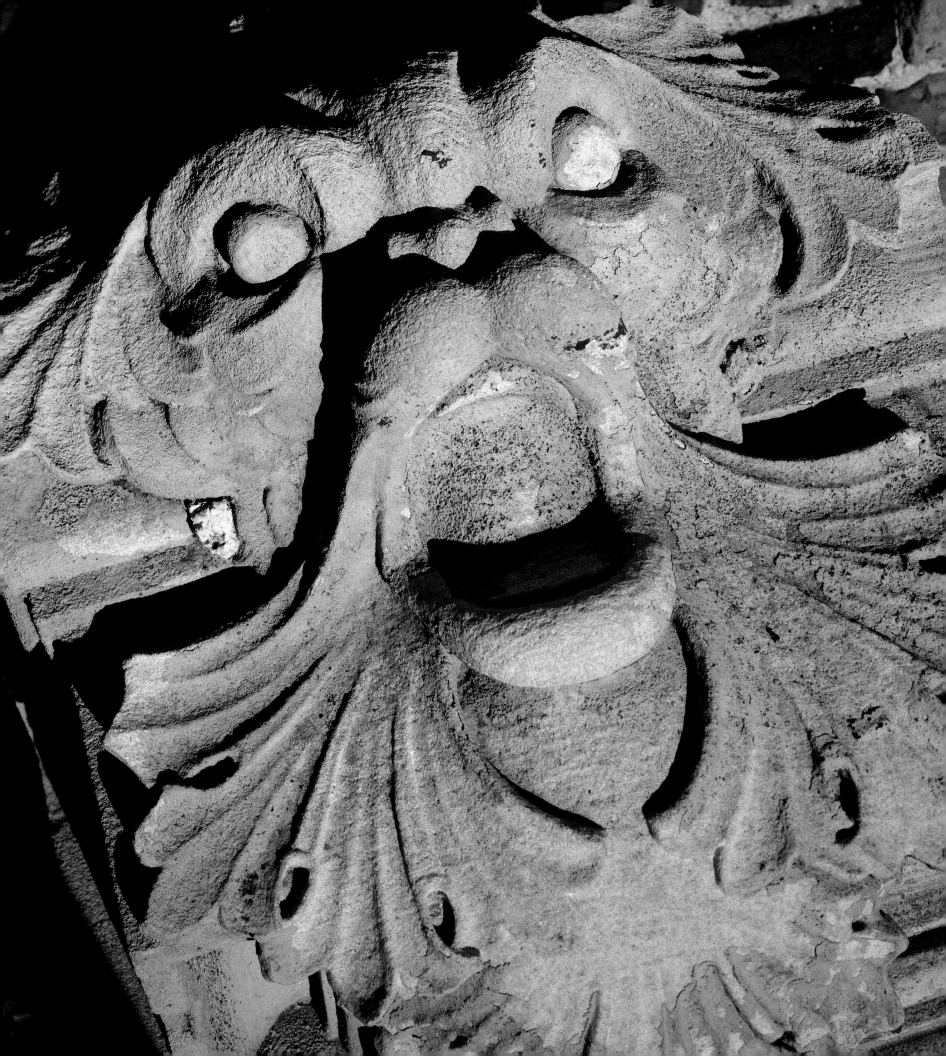

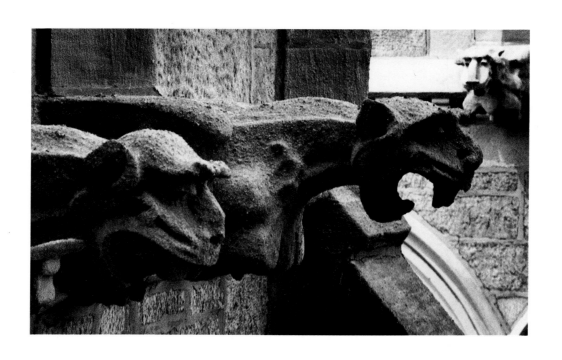

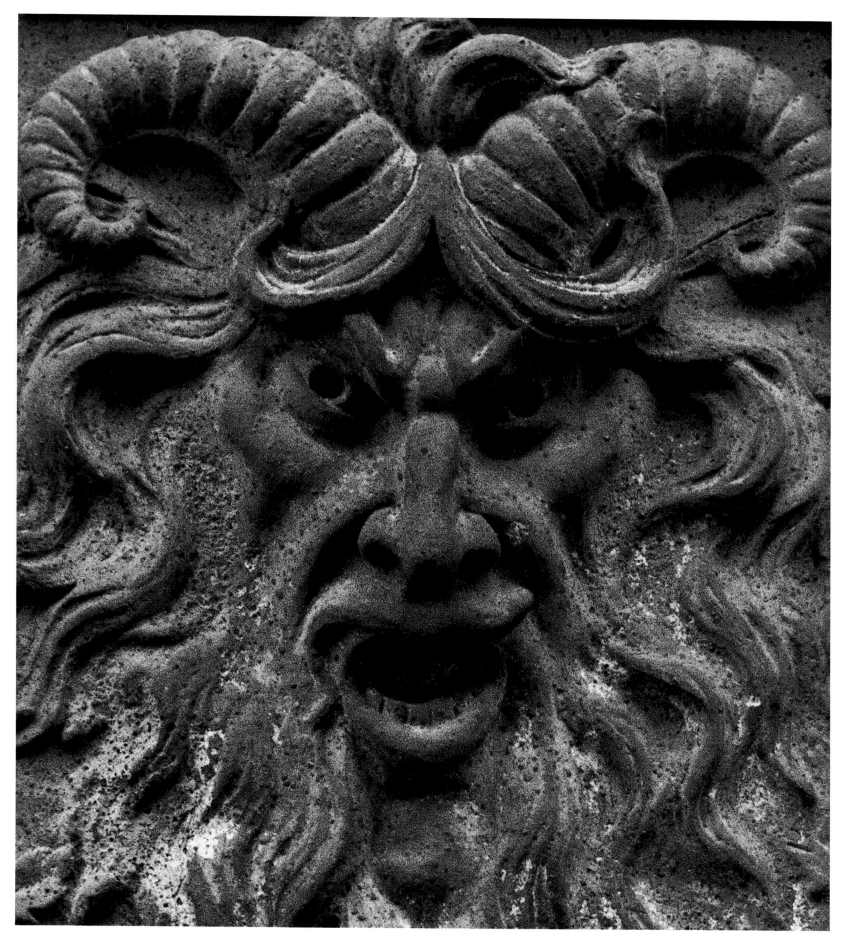

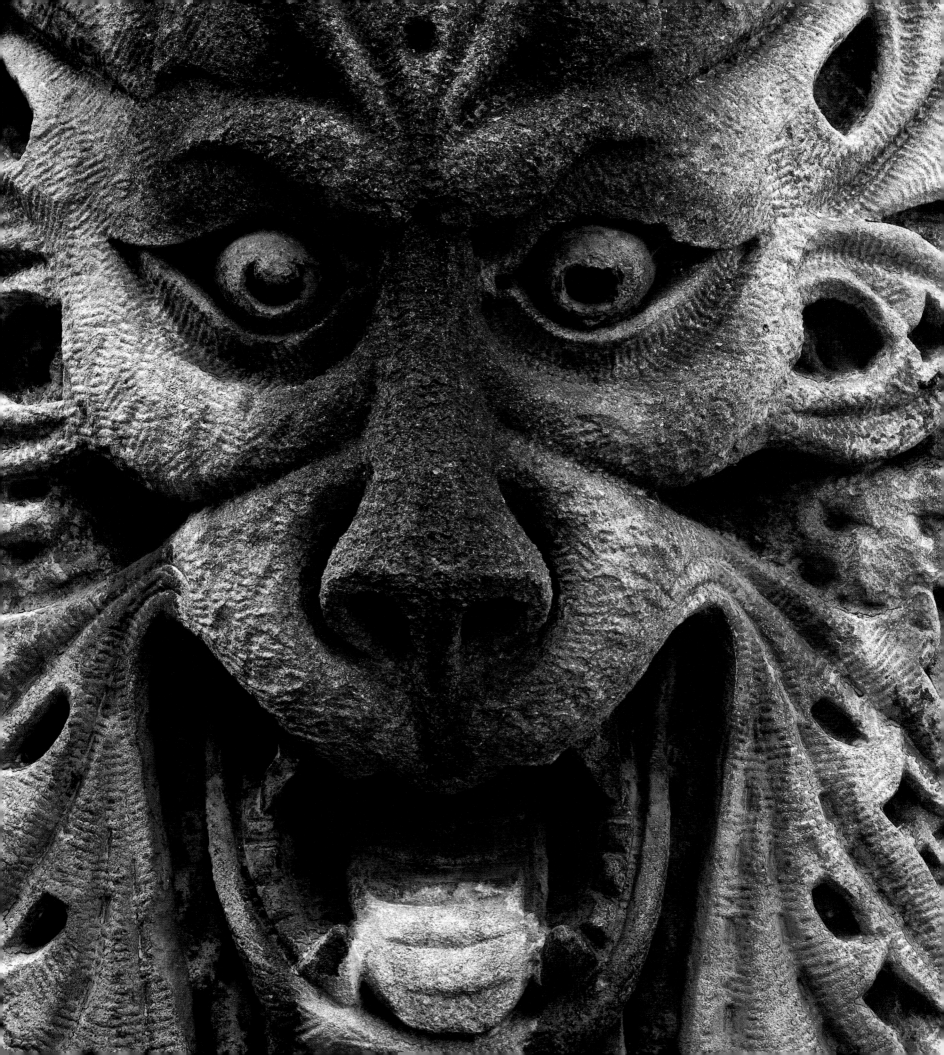

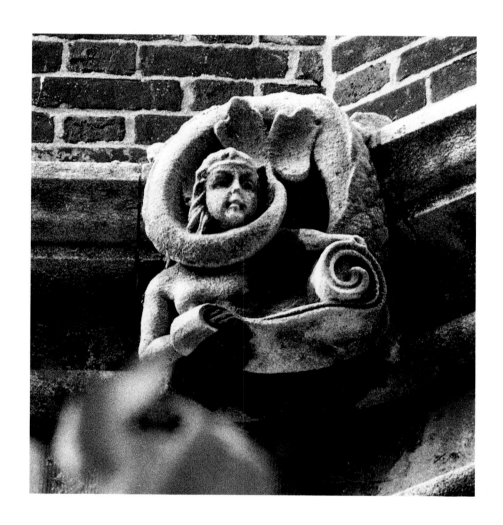

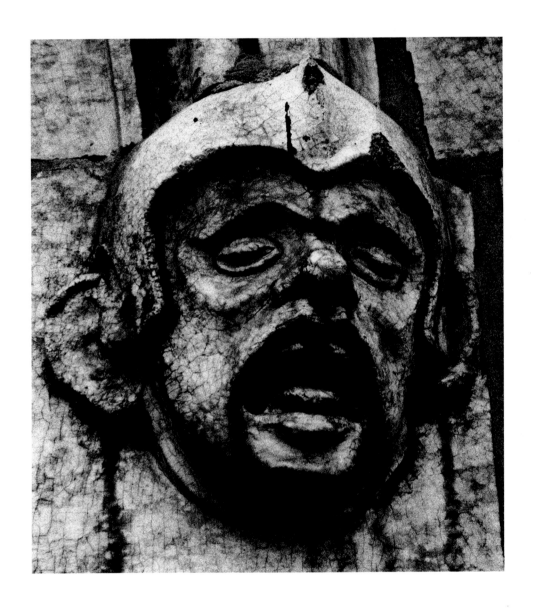

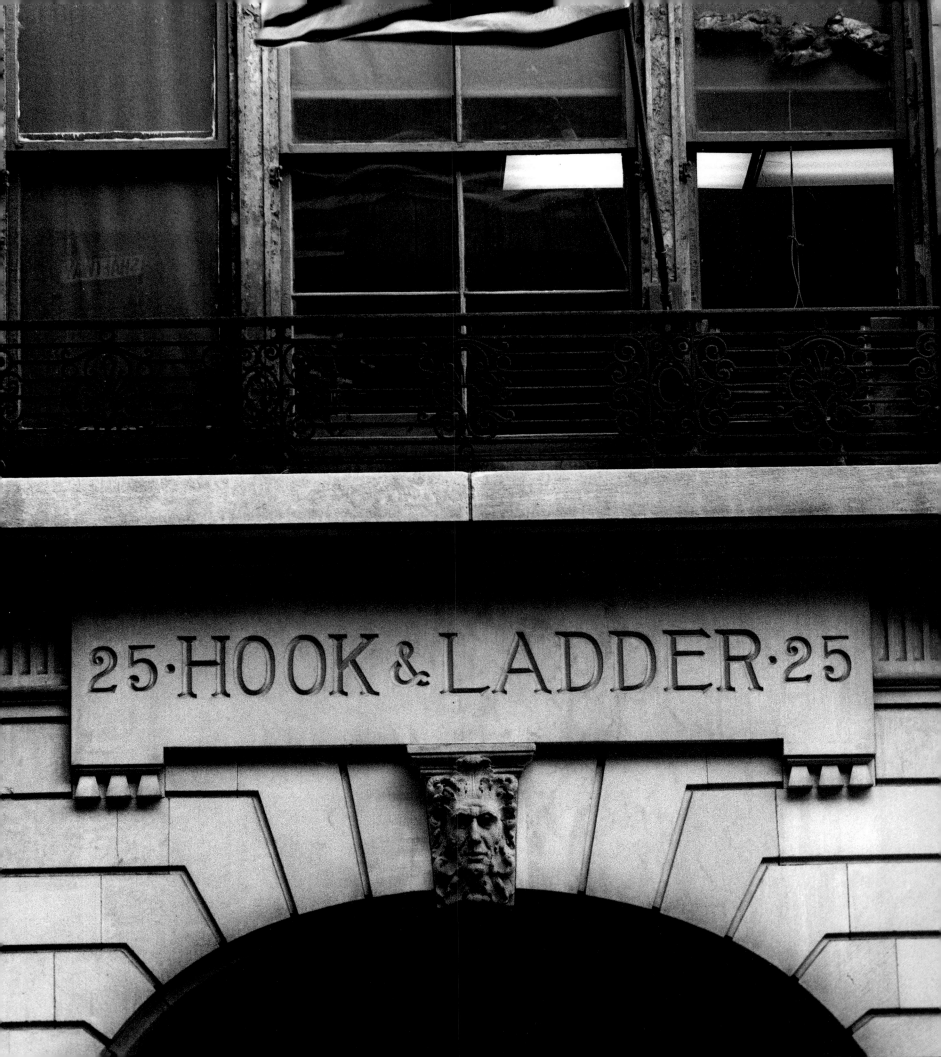

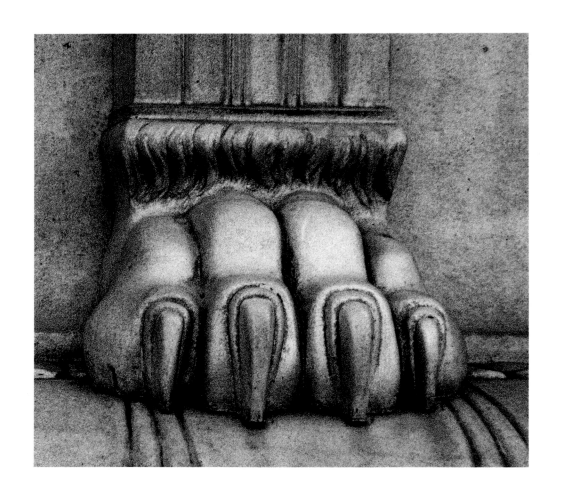

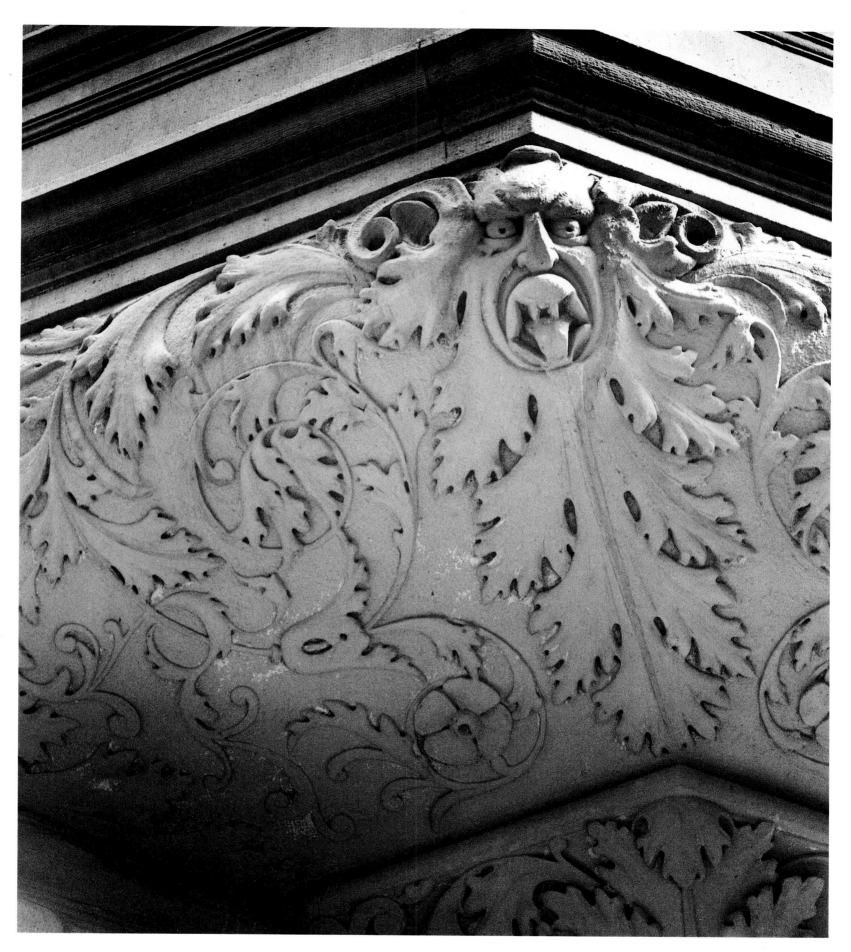

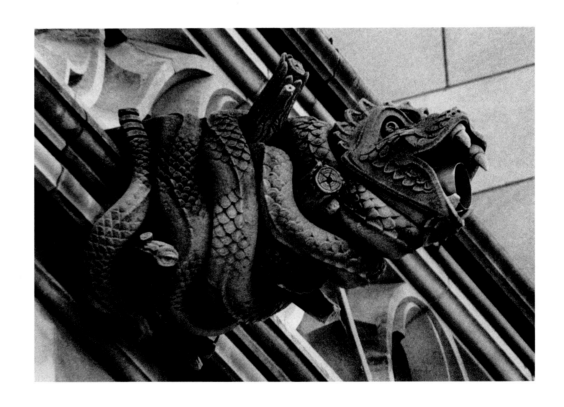

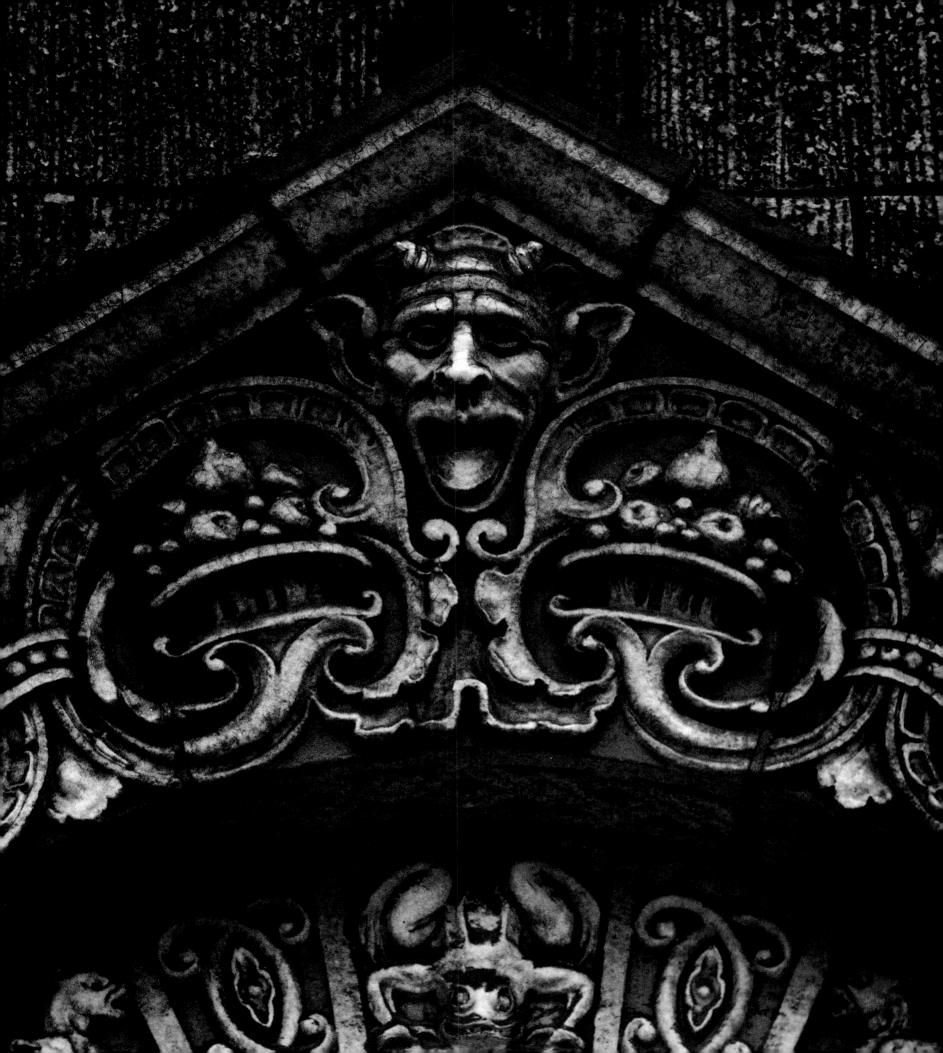

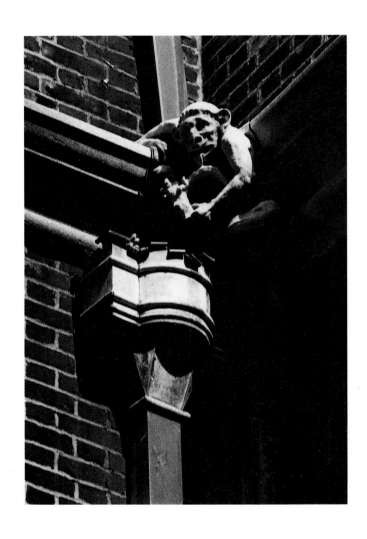

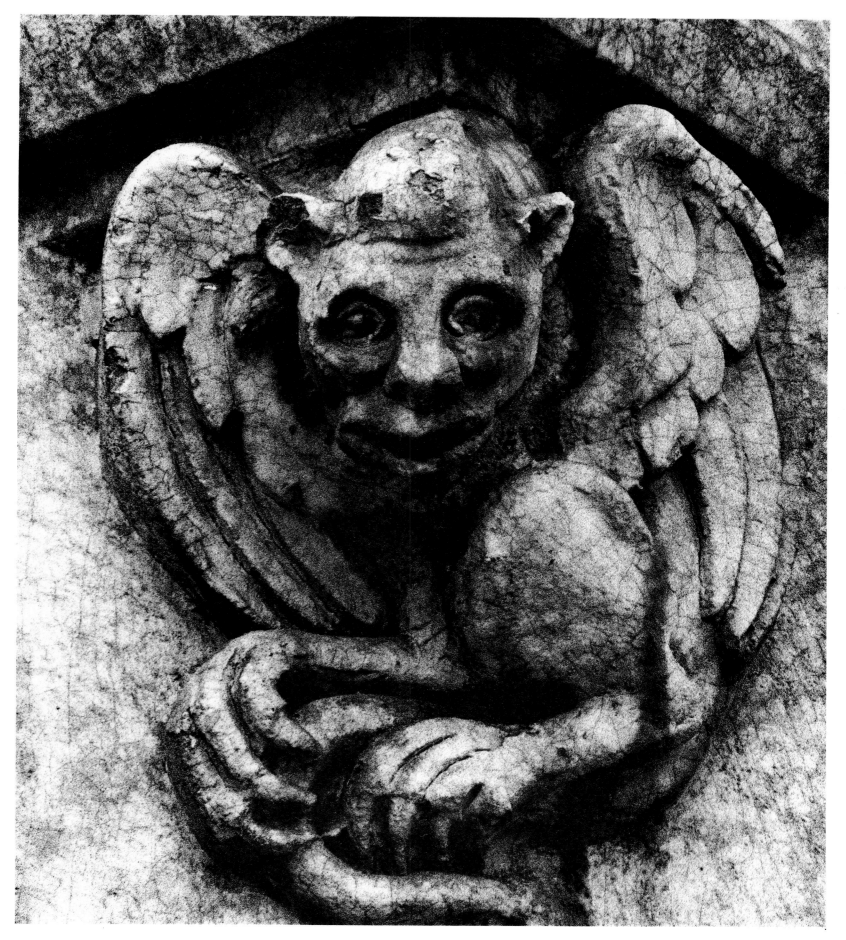

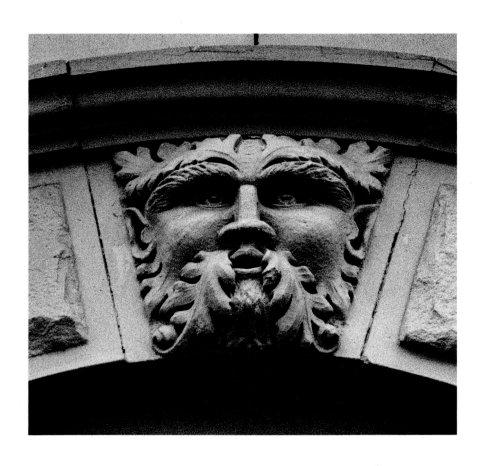

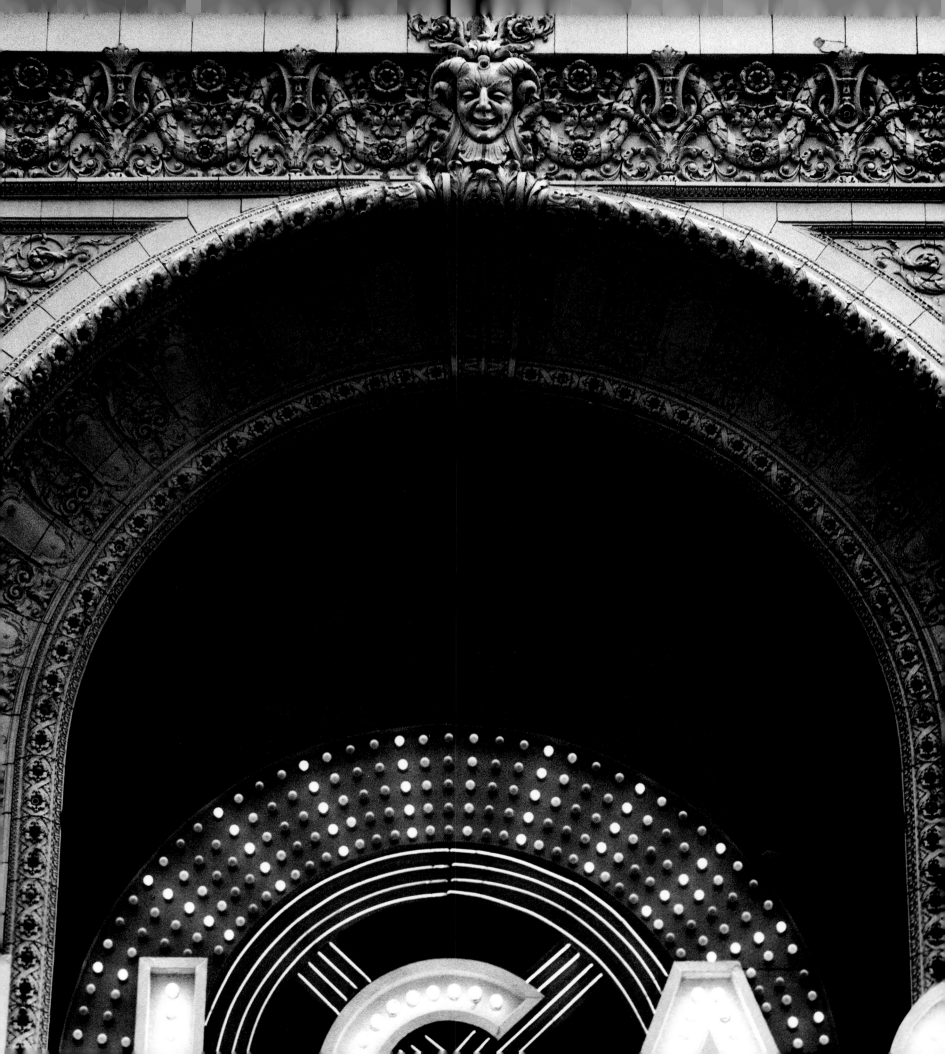

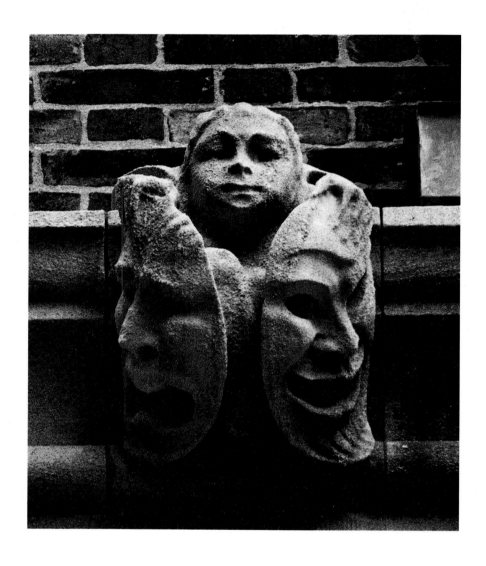

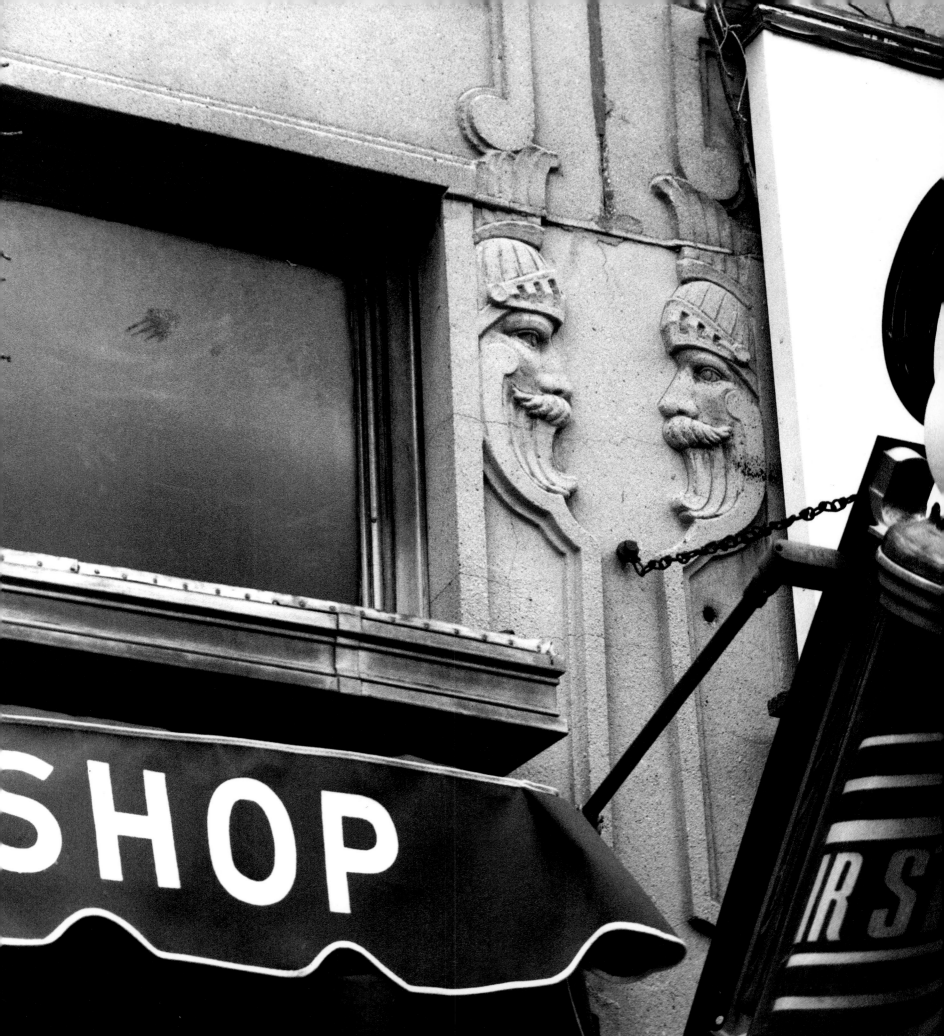

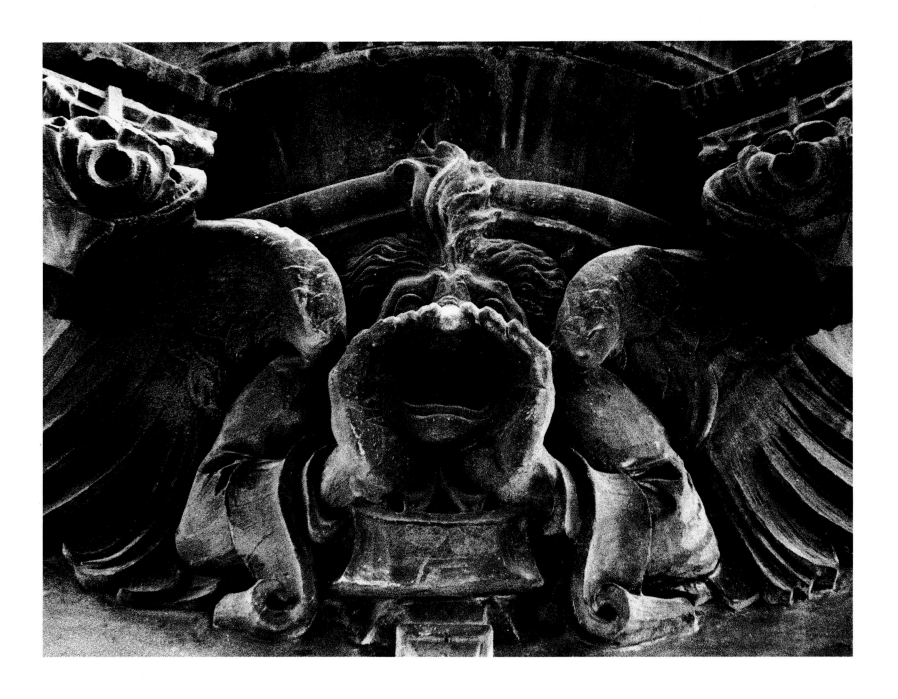

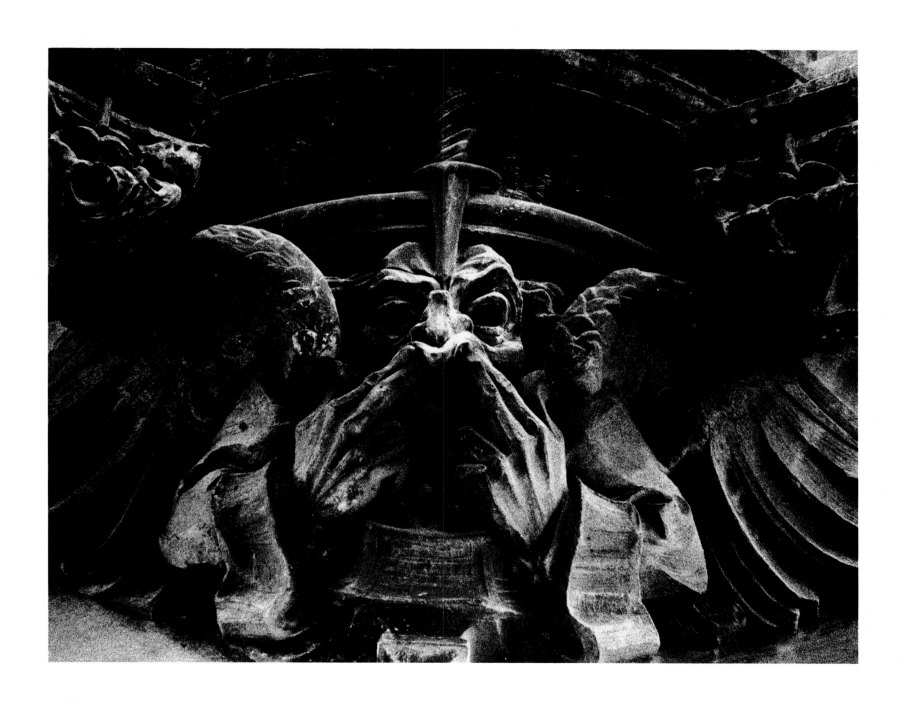

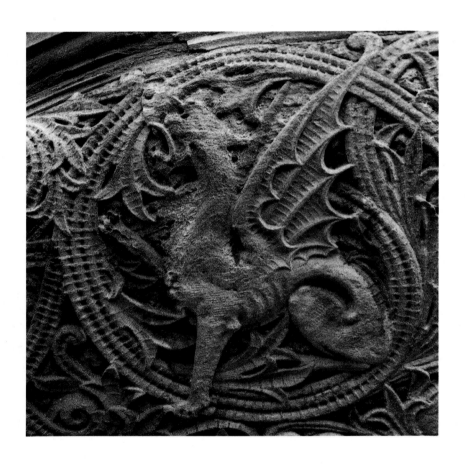

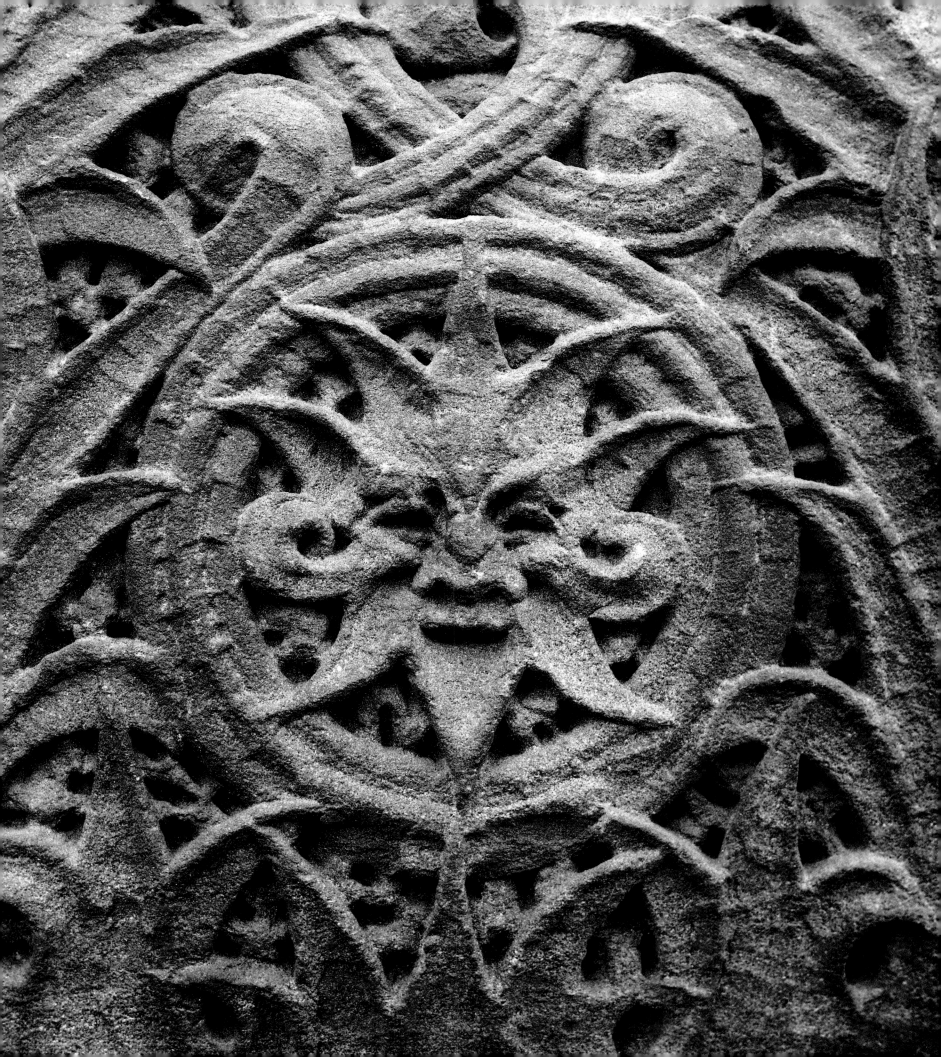

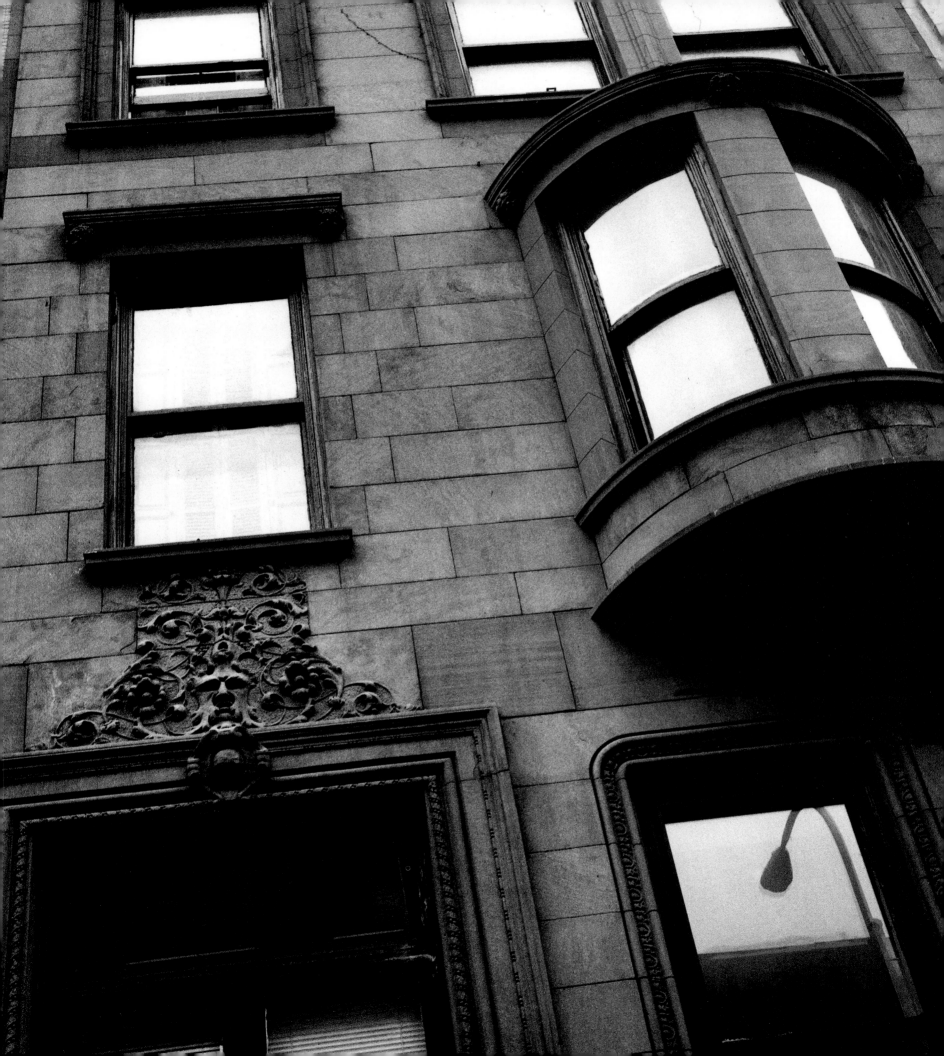

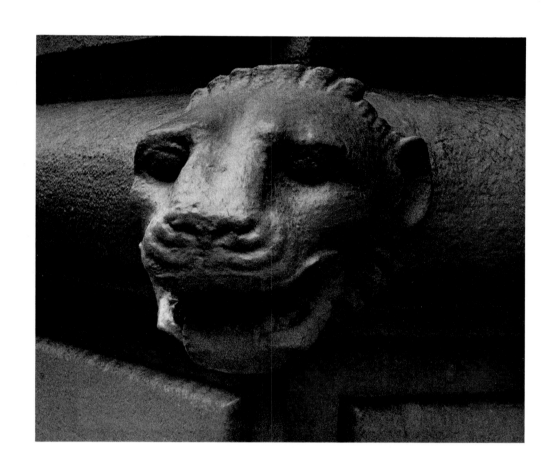

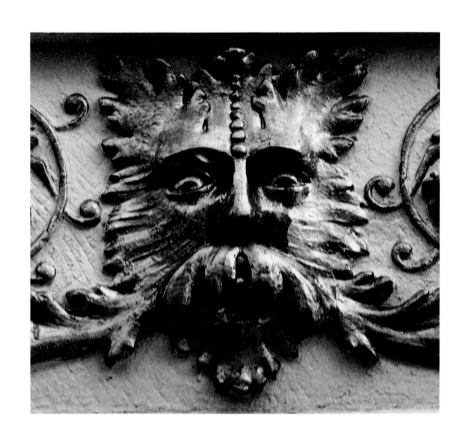

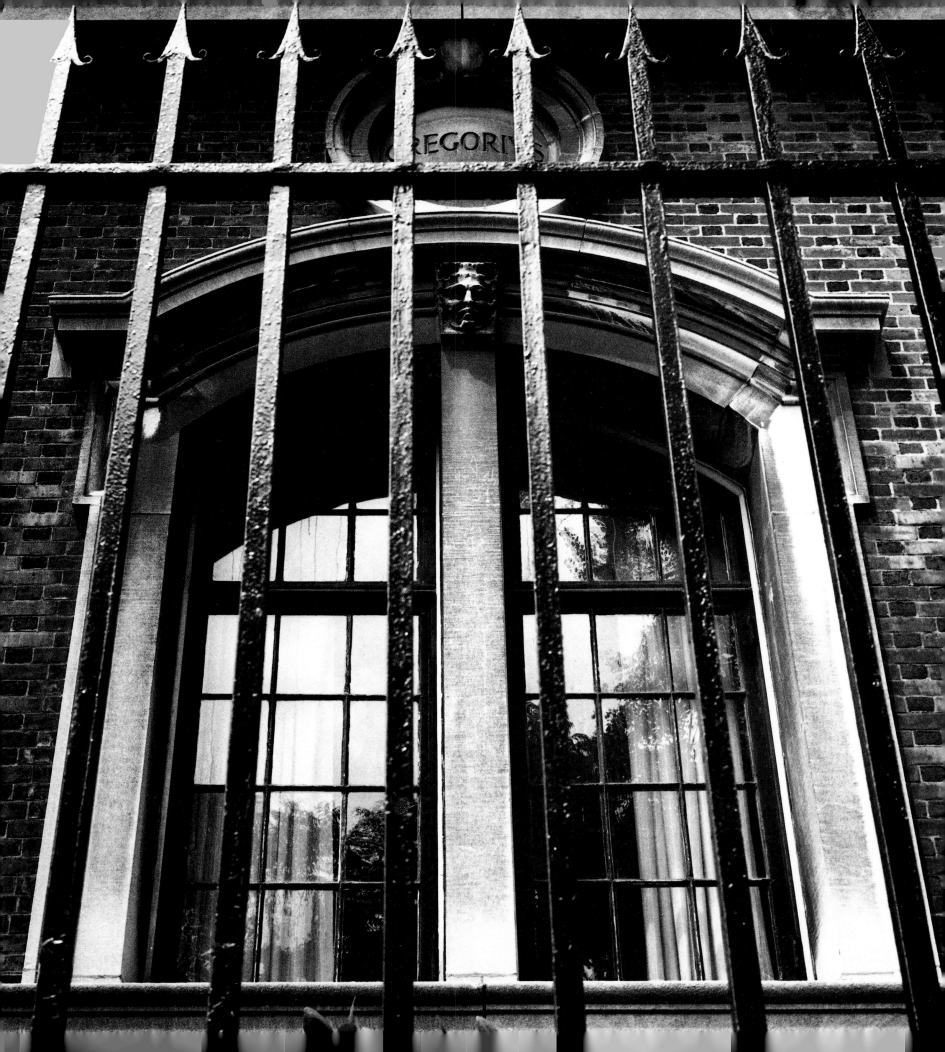

The page numbers and locations in this index refer to photographs taken between 1986 and 1988 for NIGHTMARES IN THE SKY.

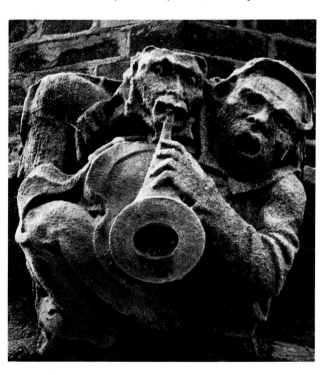

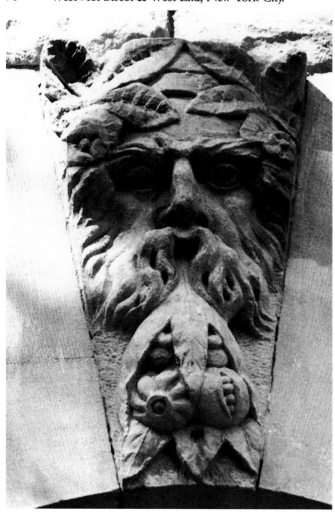

Front cover detail: 81 Irving Place, NYC. Eichner Leeds Association, Ltd.

Acknowledgements

We would like to express our genuine appreciation to those who have participated in making NIGHTMARES IN THE SKY more than a dream: Arnold Glimcher, Michael Ovitz, Kirby McCauley, Morton L. Janklow, Cynthia Cannell, Ivan Karp, Evan Blum, Lucas Janklow, Kathy O'Donnell, Paul Pollard, Emily Bickford, David Goerk, Camille Venti, John Keller, Barbara Kagan, Edward Foley, Thomas Clark, Travis Lewis, Louie Gross, Michael Lavine and Natalie Geary.

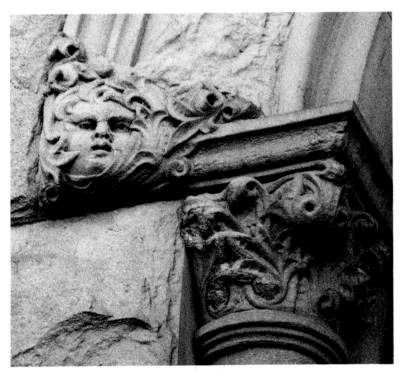

The text of this book is set in Cloister, developed in the United States by German immigrant George Trump, circa 1920. The color and duotone plates have been laser-scanned from the original photographs, and printed and bound by Toppan Printing Company (America), Inc. in Japan. The book and its jacket are printed on 105 pound U-Lite; supplied by Sanyo-Kokusaku Pulp Co. Ltd. The book and jacket were designed by Mark Pollard.